W9-DIG-399

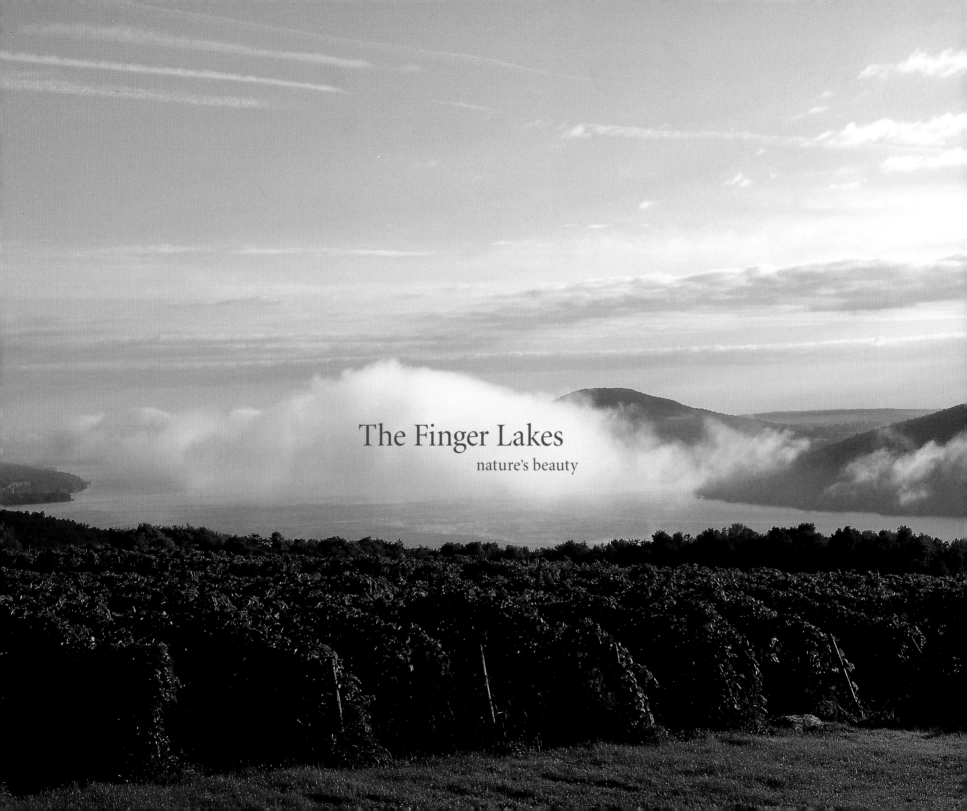

The Finger Lakes

nature's beauty

There is an old Iroquois legend

that the Finger Lakes were created by the Great Spirit pressing his hands into the land in blessing. Some of the scenery is so spectacular that the region has been called "The Switzerland of America." Geologists say that glacier action of millions of years sculptured the north to south valleys into the eleven Finger Lakes we see today. The region encompasses magnificent gorges, dramatic glens, small mountains, spectacular waterfalls, lakes, and rivers. Hundreds of miles of hiking, boating, canoeing, snowshoeing, and skiing await the visitor and resident. Come visit this enchanted Finger Lakes region.

The Finger Lakes

nature's beauty

Den Linnehan

McBooks Press
Ithaca, NY 14850
www.mcbooks.com

Published by McBooks Press 2008
Copyright © 2008 by Den Linnehan

Original concept, book design, and all photographs by Den Linnehan.
Digital imaging by Panda Musgrove.

Library of Congress Cataloging-in-Publication Data

Linnehan, Den.
 The Finger Lakes : nature's beauty / by Den Linnehan.
 p. cm.
 Includes index.
 ISBN 978-1-59013-160-2 (cloth : alk. paper)
 1. Finger Lakes (N.Y.)—Pictorial works. 2. Finger Lakes Region (N.Y.)—Pictorial works. 3. Natural history Finger Lakes Region—New York (State)—Pictorial works. 4. Landscape Finger Lakes Region—New York (State)—Pictorial works. 5. Landscape photography Finger Lakes Region—New York (State) I. Title.
 F127.F4L56 2008
 974.7'800222--dc22

 2007042446

Visit the McBooks Press web site at www.mcbooks.com

Printed in China
9 8 7 6 5 4 3 2 1

This book is dedicated to my wife, Elaine, who has waited countless hours with me for that perfect light to emerge.

Front Cover Plunge pool at Buttermilk Falls State Park, *Back Cover* Canandaigua Lake sunset, Lower Falls at Fillmore Glen State Park, Letchworth State Park, Chittenango Falls State Park, dame's rocket, Bristol Hills, Honeoye Lake, Ithaca Falls, water lily *Front Flap* Fillmore Glen State Park, Conesus Lake *Rear Flap* Harriet Hollister Spencer State Recreation Area, hay bales near Prattsburgh *Page 1* Canandaigua Lake, *Page 3* Canadice Lake

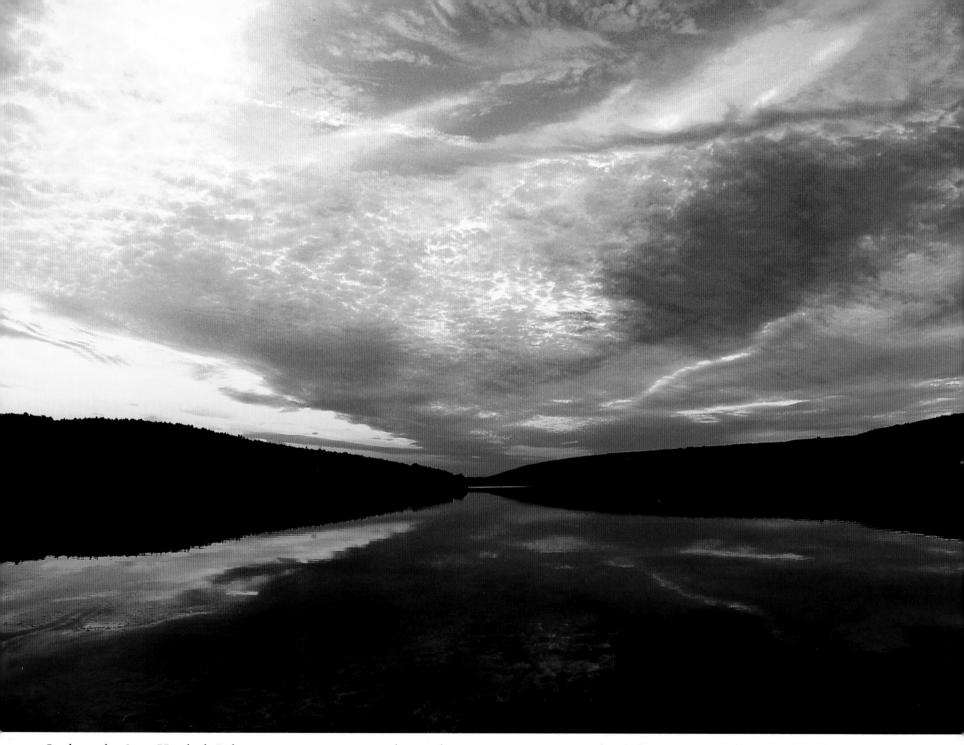

In the early 1800s Hemlock Lake was a summer resort with steamboats traversing its cottage-lined shores. In 1876, the City of Rochester completed a water project that still draws the city's drinking water from the lake.

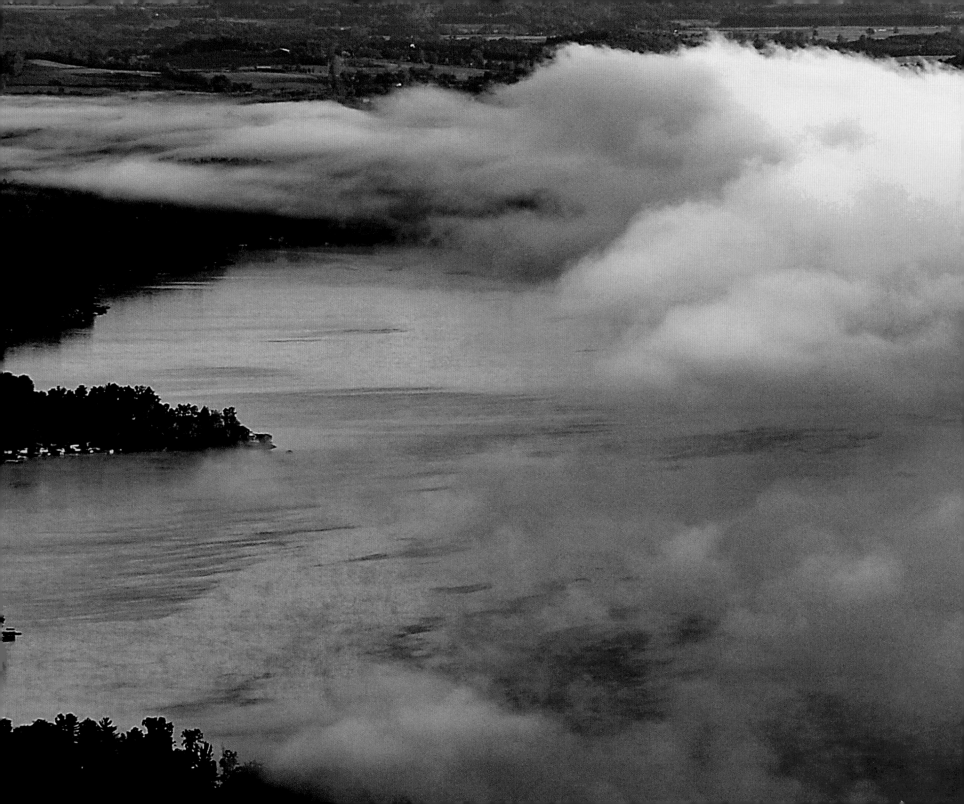

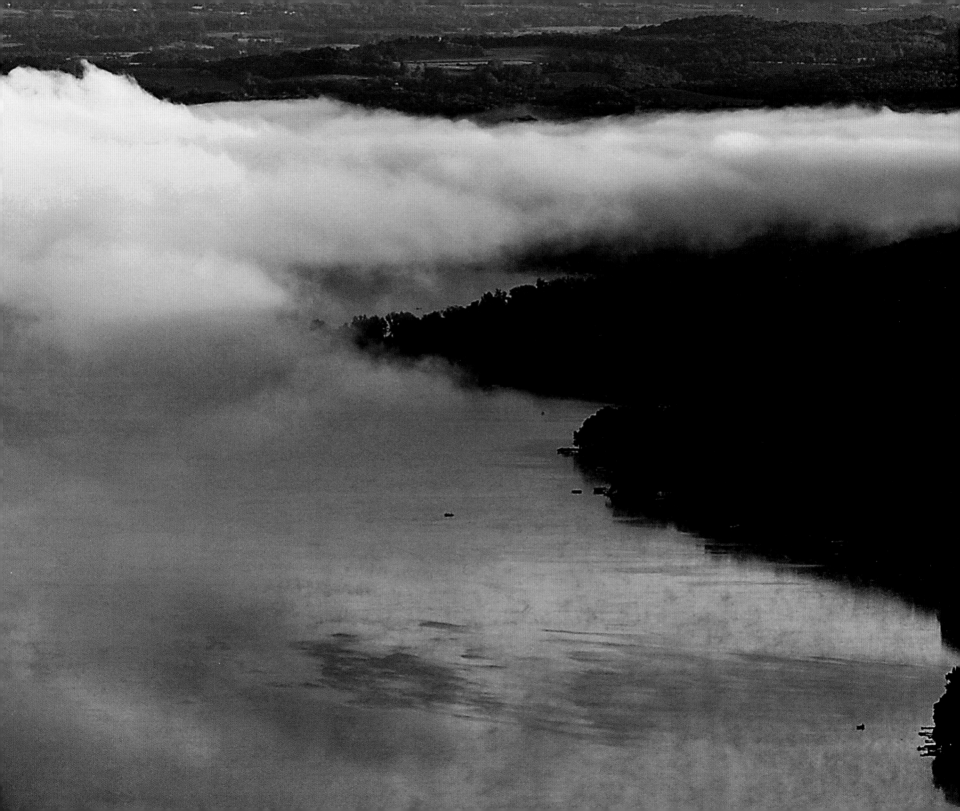

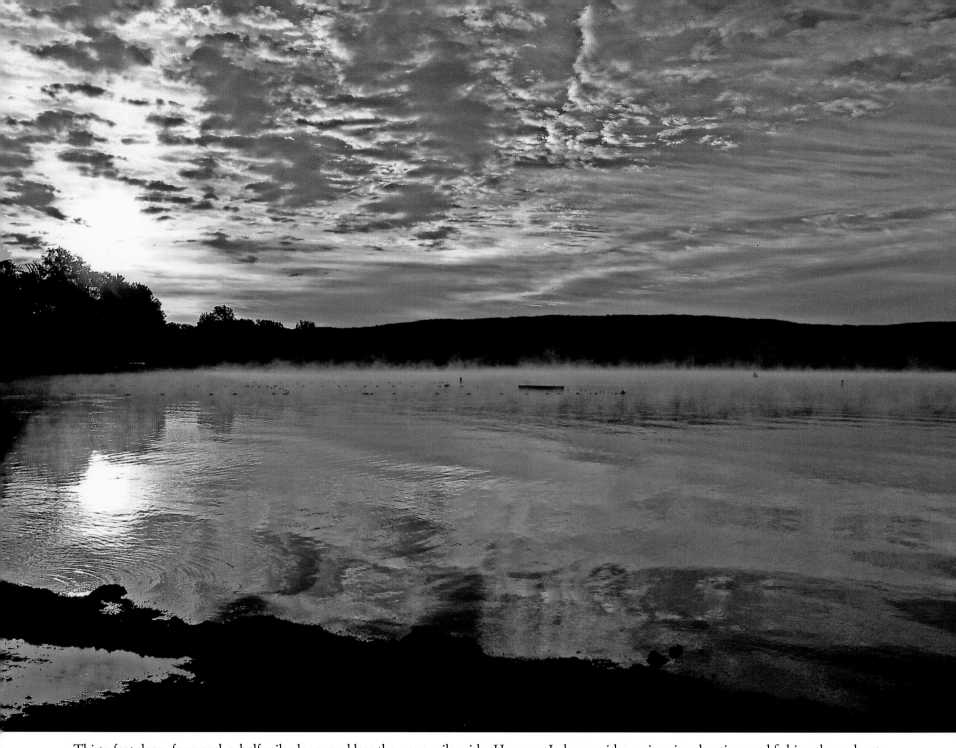

Thirty feet deep, four-and-a-half miles long, and less than one mile wide, Honeoye Lake provides swimming, boating, and fishing throughout the seasons. *Previous Pages:* Mist rises over Honeoye Lake at Harriet Hollister Spencer State Recreation Area.

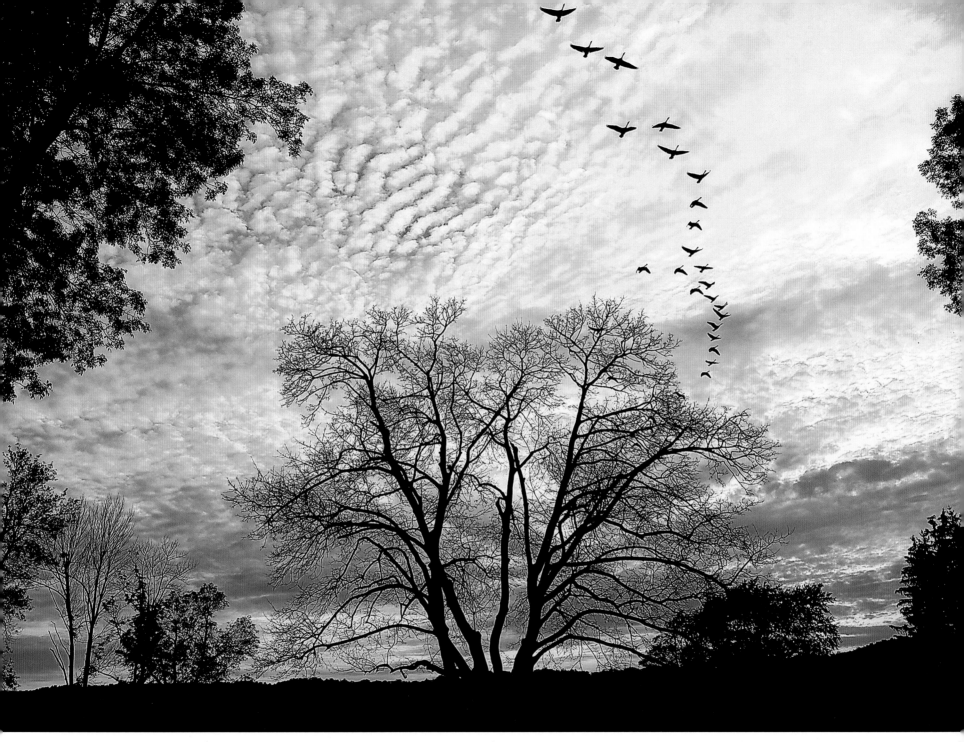

A flock of geese was feasting on the grass in Hemlock Lake Park while I was getting ready to photograph the sunset. Something startled them and they began circling—two times, then three, creating this idyllic scene.

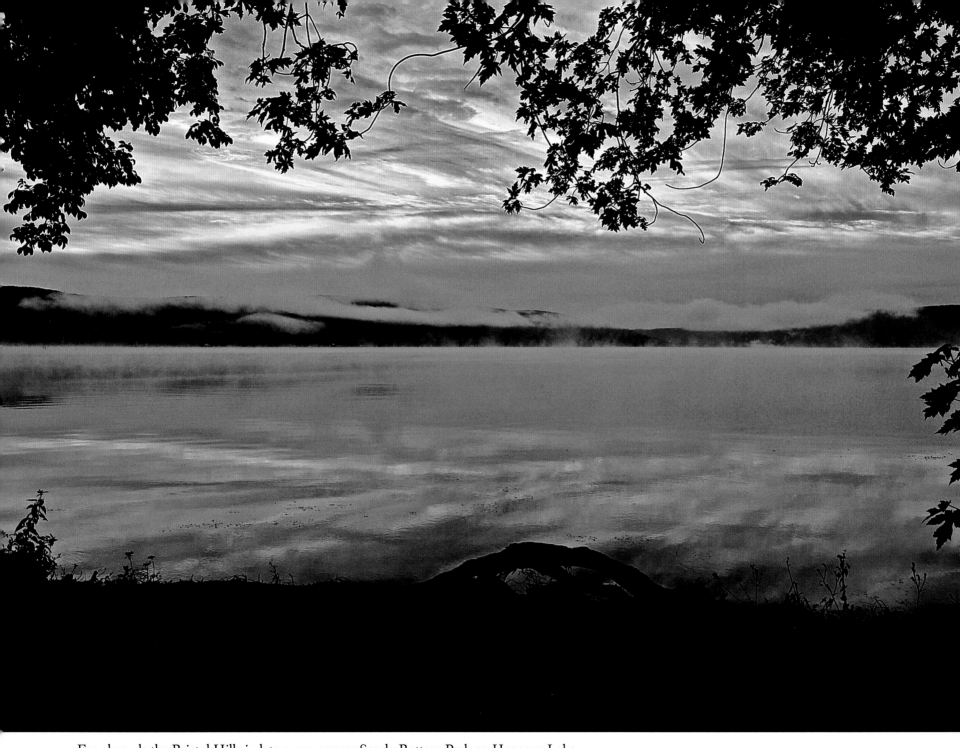

Fog shrouds the Bristol Hills in late summer near Sandy Bottom Park on Honeoye Lake.

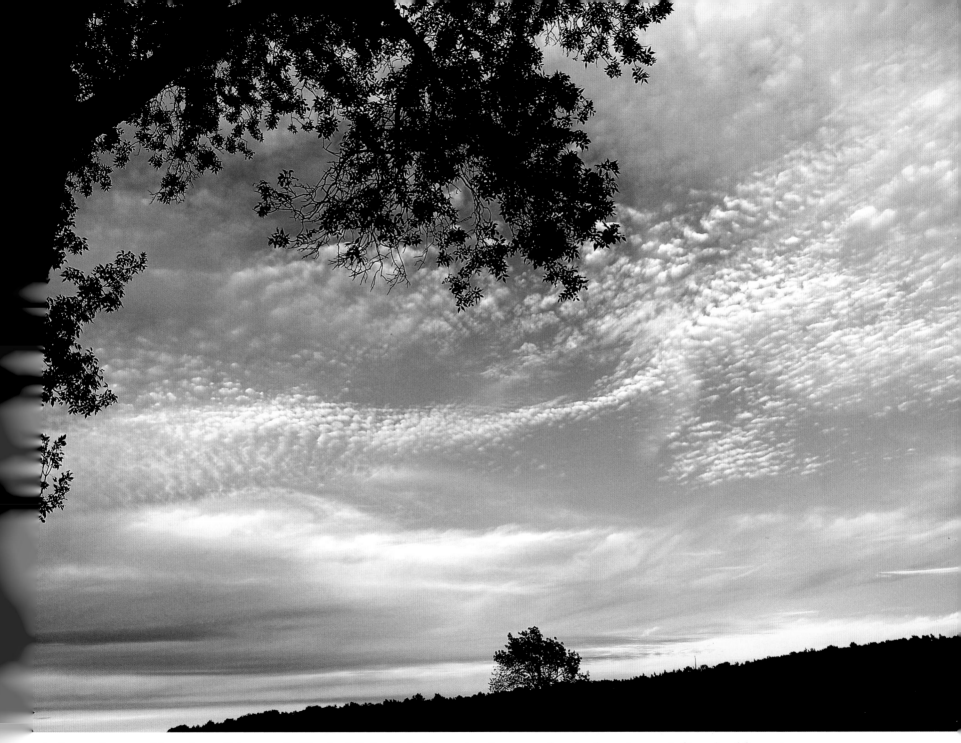

As I was photographing a beautiful sunset in Hemlock Lake Park, I turned to the east and noticed a unique spiraling cloud formation.

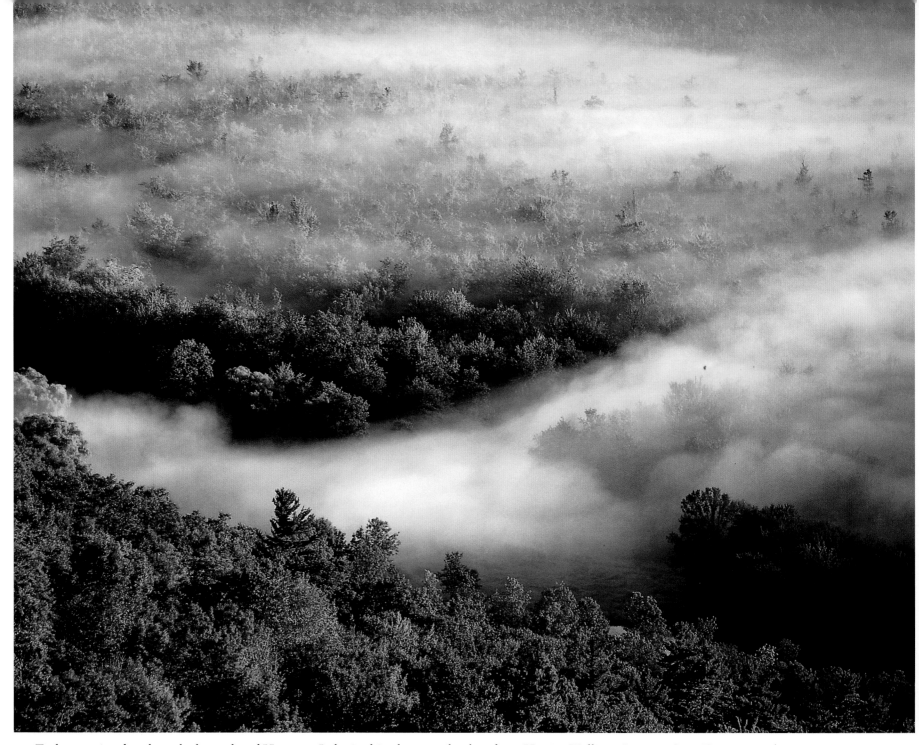

Early morning fog shrouds the outlet of Honeoye Lake in this photograph taken from Harriet Hollister Spencer State Recreation Area.

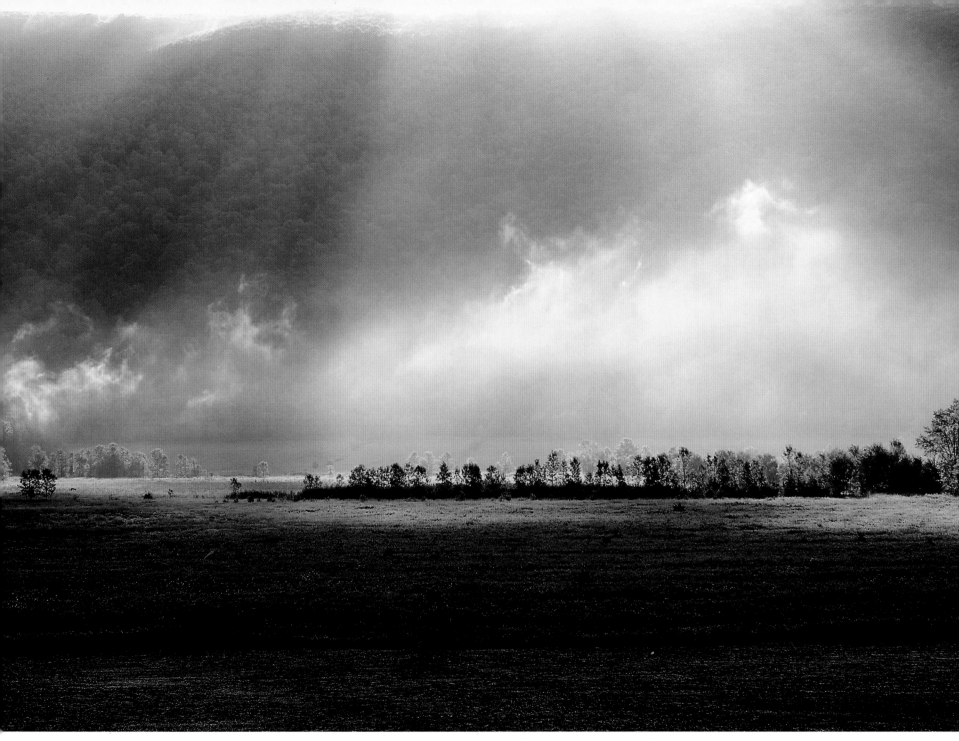

Fog climbs the Bristol Hills in the Honeoye Creek Wildlife Management Area. Cool mornings and warm afternoons are common in the Finger Lakes, where temperature fluctuations within a day vary greatly.

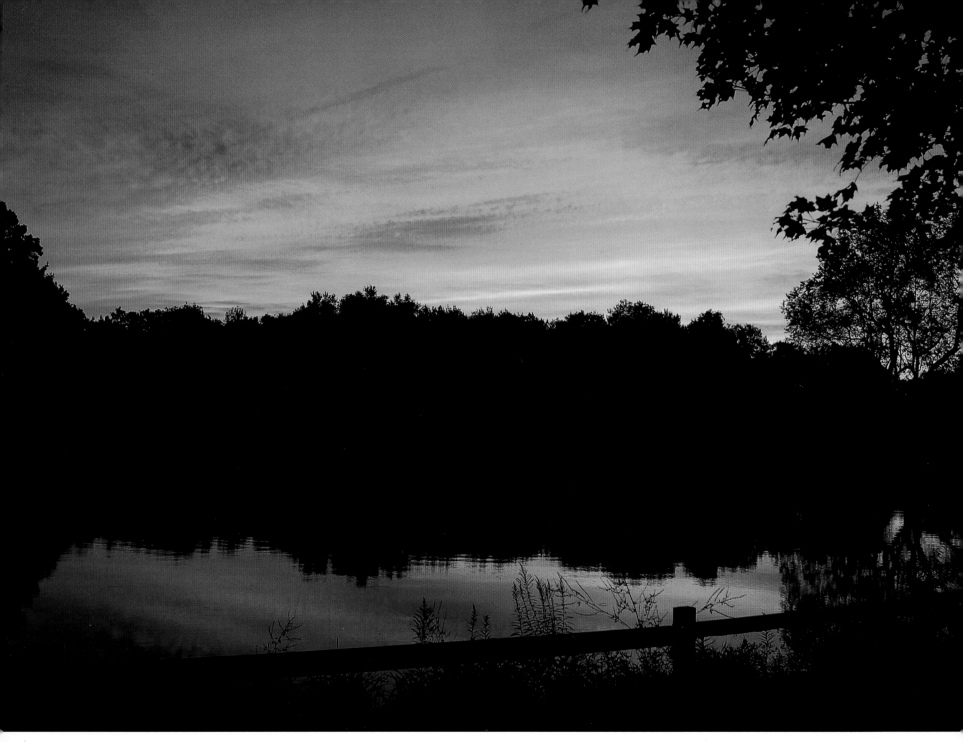

The Cummings Nature Center near Naples has many short trails, a spring maple syrup festival, summer sheep shearing, fall foliage, snowshoeing, horse-drawn sled rides, and cross-country skiing.

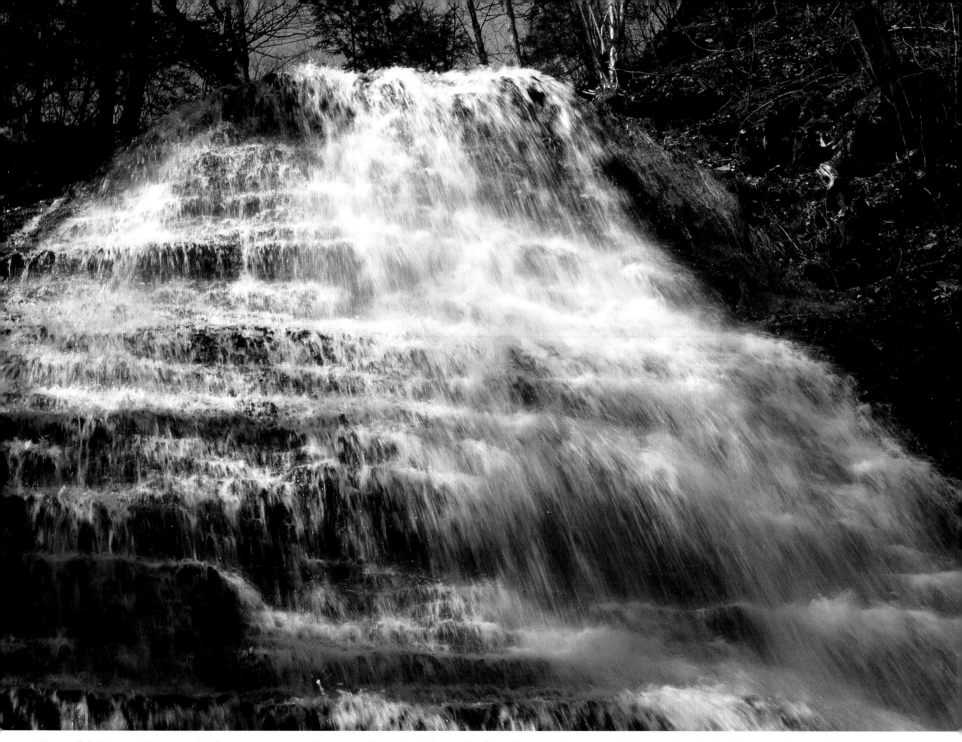

Beautiful Grimes Glen is tucked into a ravine in the town of Naples. This is the first of two 60-foot waterfalls on a short hike along Naples Creek.

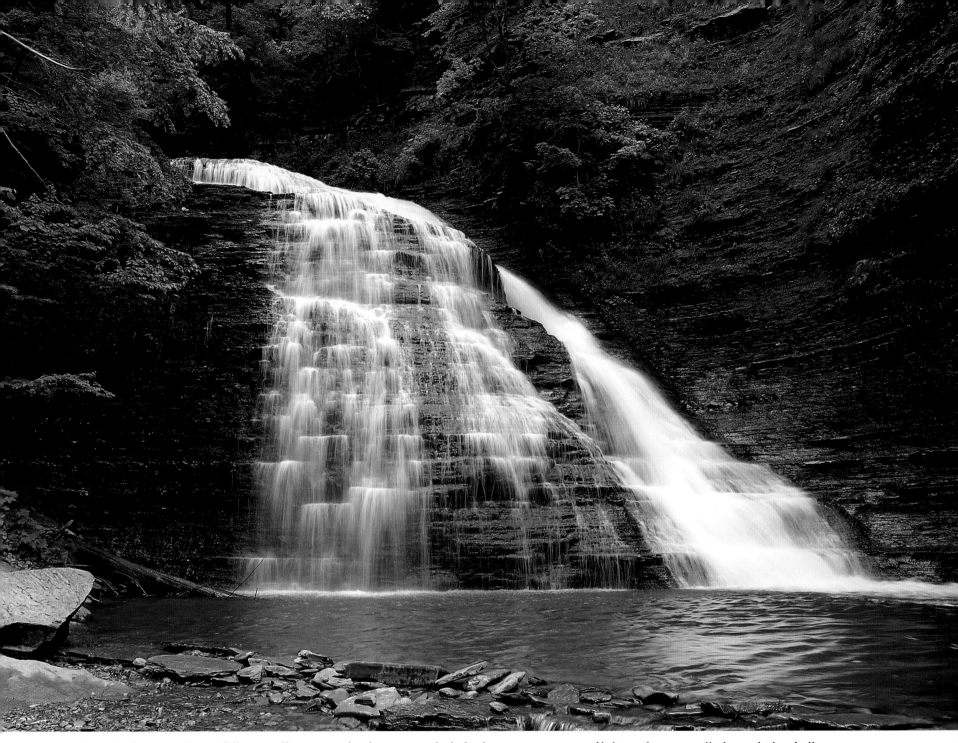

To reach the second waterfall—equally spectacular, but very secluded—bring an extra pair of hiking shoes to walk through the shallow water. The trail ends here as cliffs tower above you on all sides.

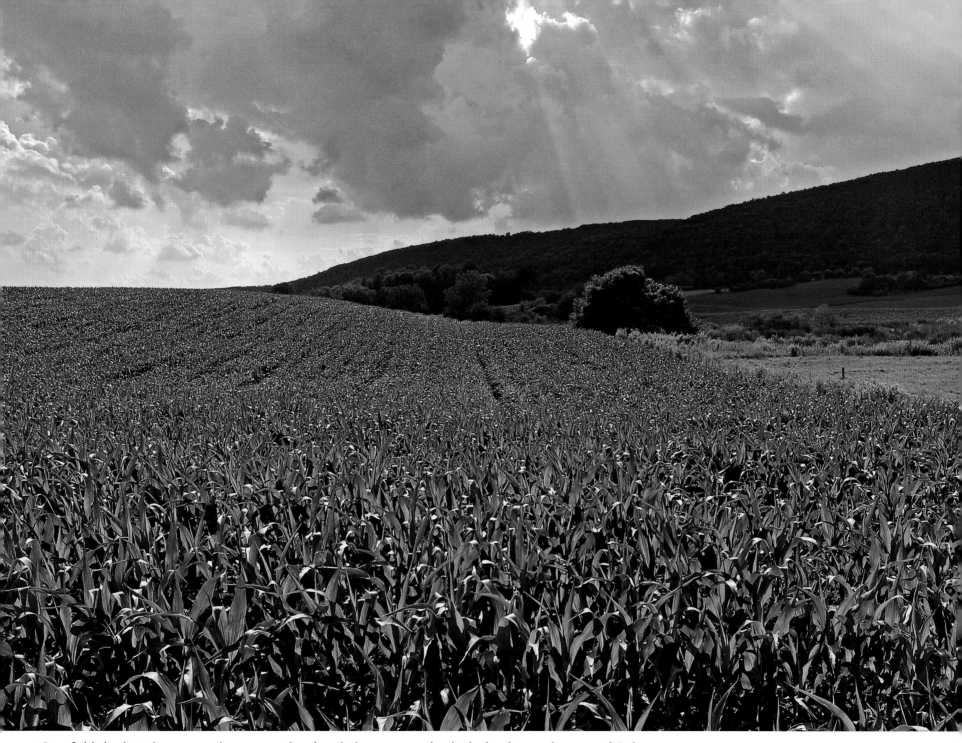

Cornfields bask in the summer heat as streaks of sunlight penetrate the thick clouds near the town of Cohocton.

A Cohocton sunrise.

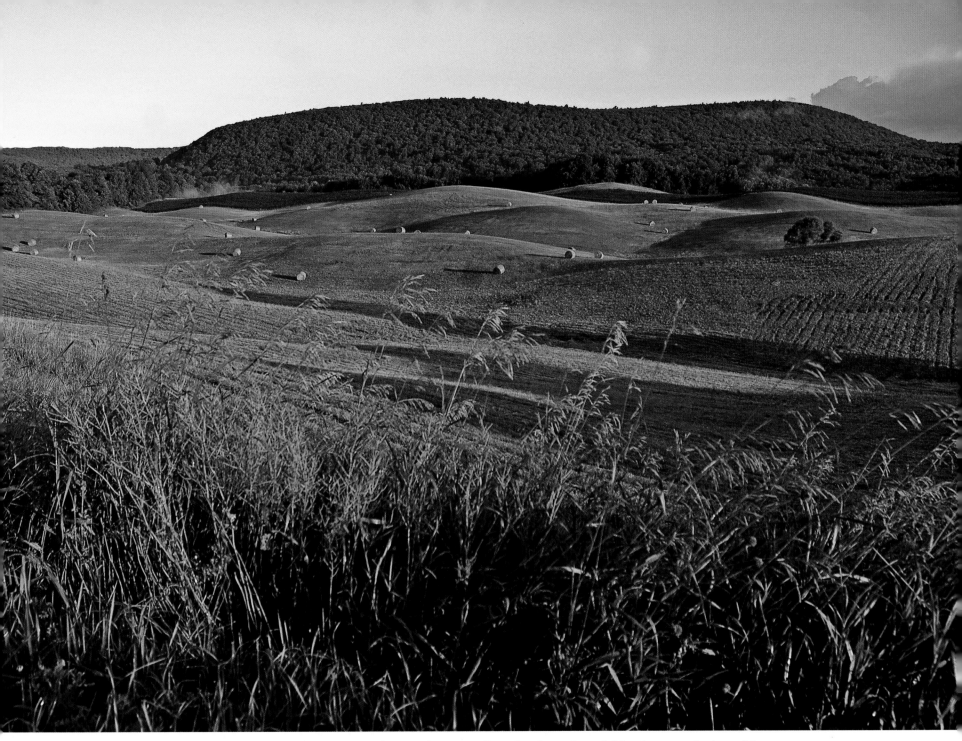

Surrounded by 2,000-foot mountains, the scenic countryside near the town of Naples abounds in fields of corn and wheat. Nature preserves and wildlife management areas protect many thousands of acres.

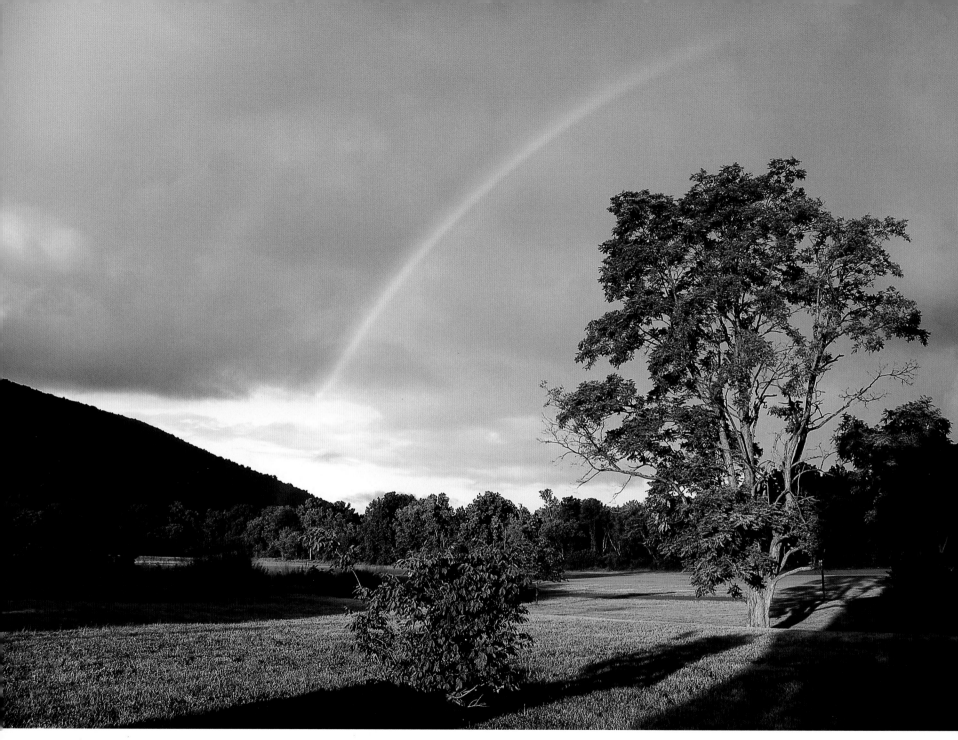

At a community recreation area within the town of Naples, I enjoyed a rainbow at sunrise.

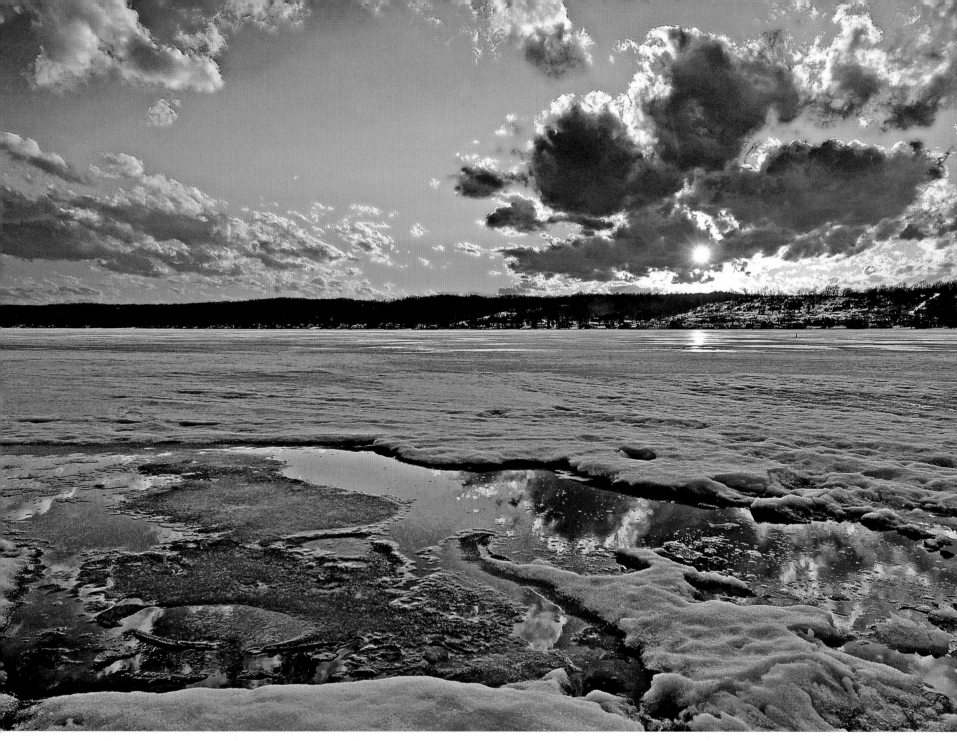

On a March evening, sunset begins to stream across the mostly frozen Conesus Lake.

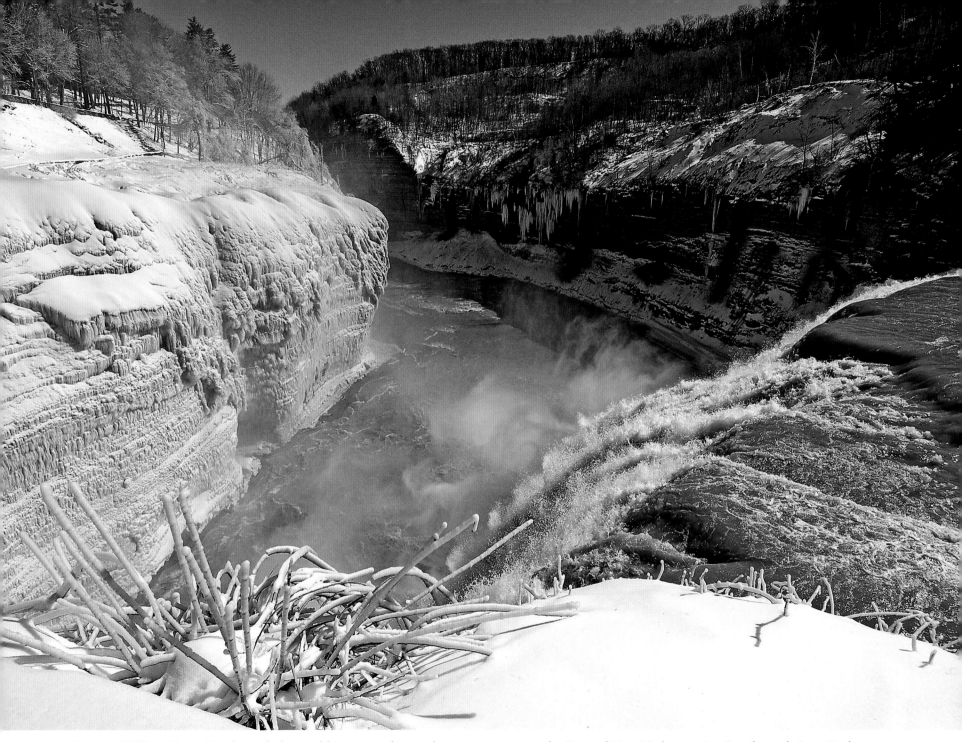

In 1907 William Pryor Letchworth donated his estate of more than 14,000 acres to the State of New York, creating Letchworth State Park.
The 600-foot gorge walls guide the frigid Genesee River down its icy path.

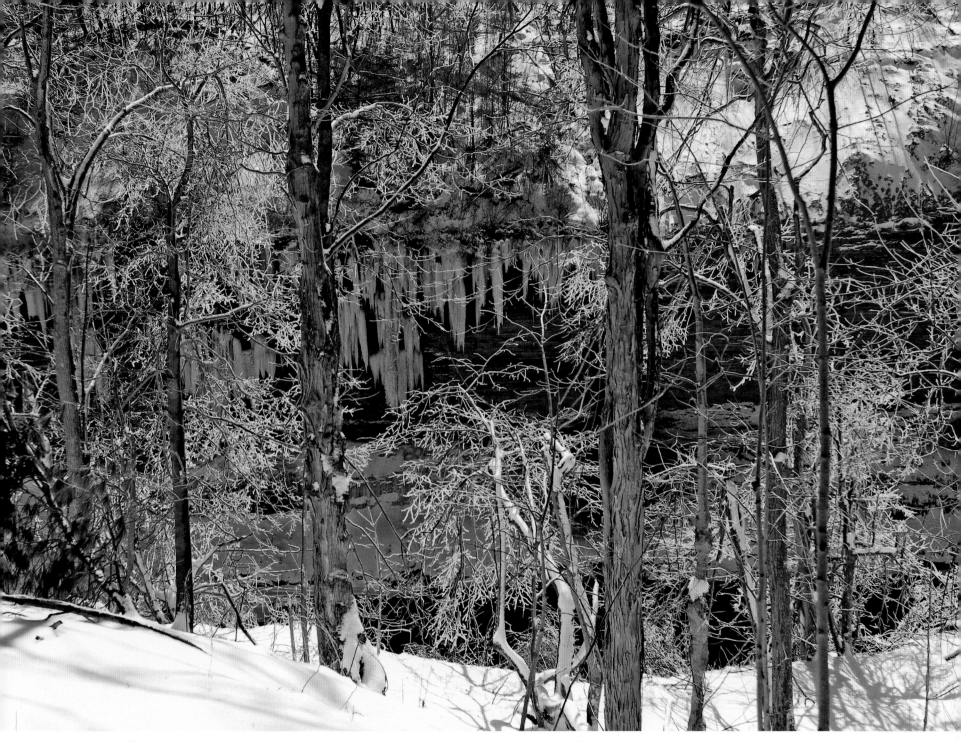

Letchworth offers numerous indoor and outdoor activities, including more than sixty trails—some accessible year-round. For the more adventurous, there are guided raft trips down the Genesee River or hot-air-balloon rides over the park.

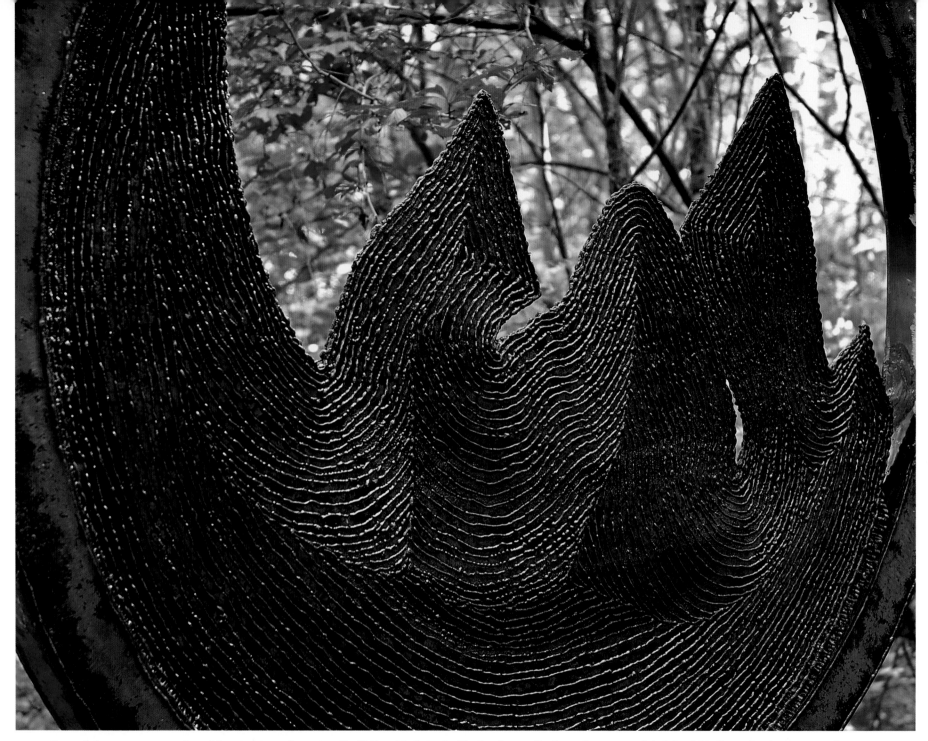

One of the most unusual and fascinating places in all of New York is Griffis Sculpture Park in the town of Ashford Hollow. Sculptures made by Mr. Griffis and other artists are strategically placed over 400 acres of land.

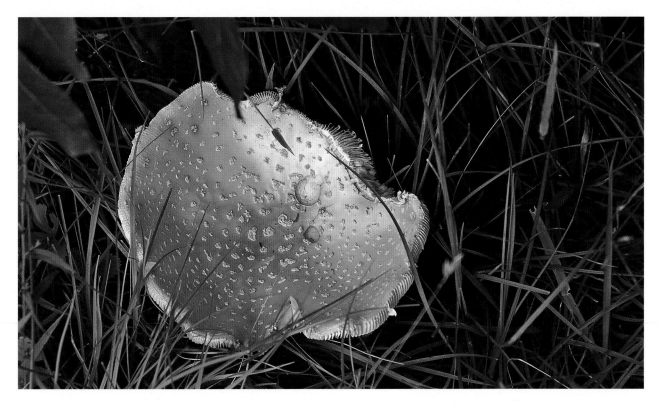

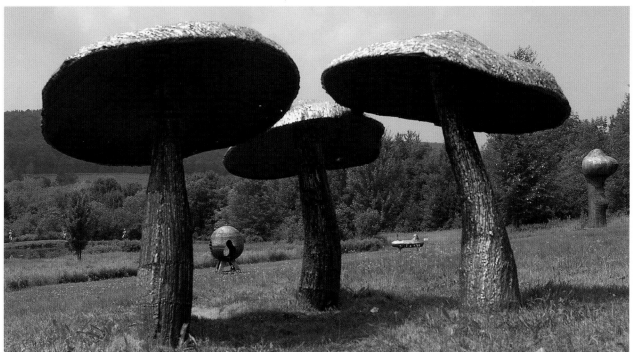

There are numerous trails within Griffis Sculpture Park. Here real and metal mushrooms coexist!

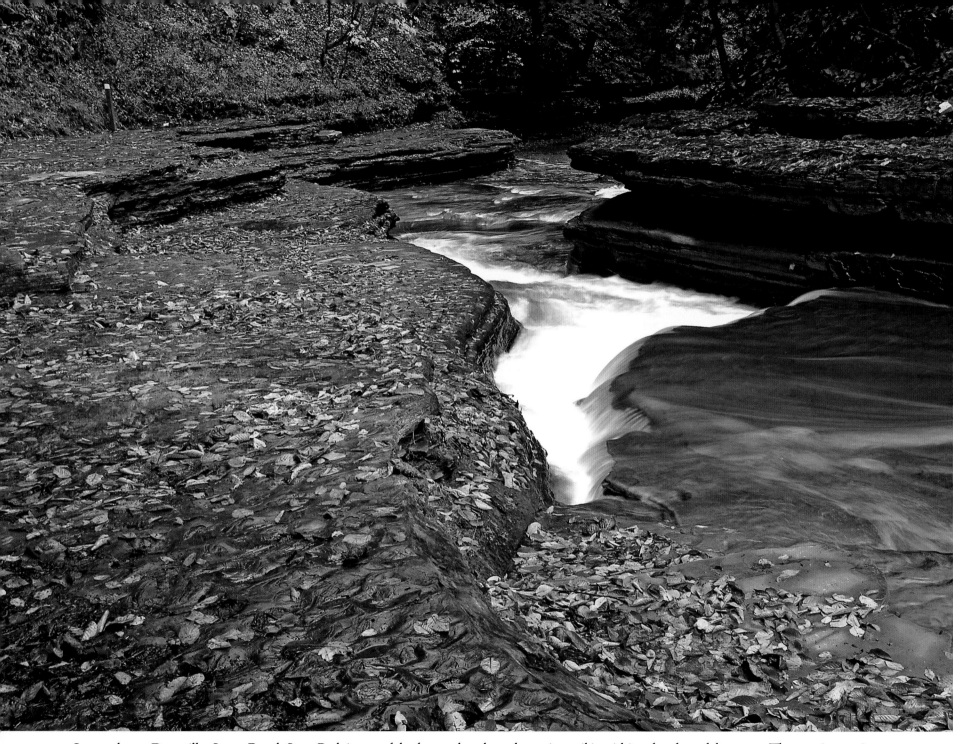

Located near Dansville, Stony Brook State Park is one of the few parks where the entire trail is within a few feet of the water. The terrain consists of woodlands, the gorge itself, and rugged cliffs that rise hundreds of feet above the Gorge Trail.

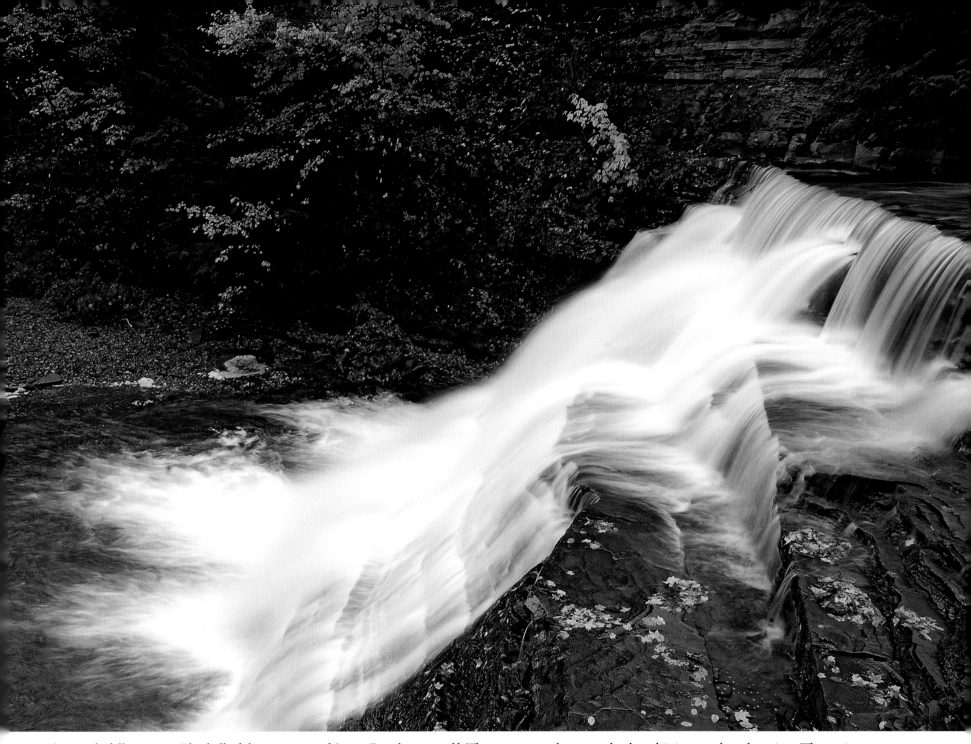

One early fall morning I had all of the 550 acres of Stony Brook to myself. There are many larger parks, but this is one of my favorites. The major trail is the Gorge Trail, about one mile in length, offering splendid views with little climbing.

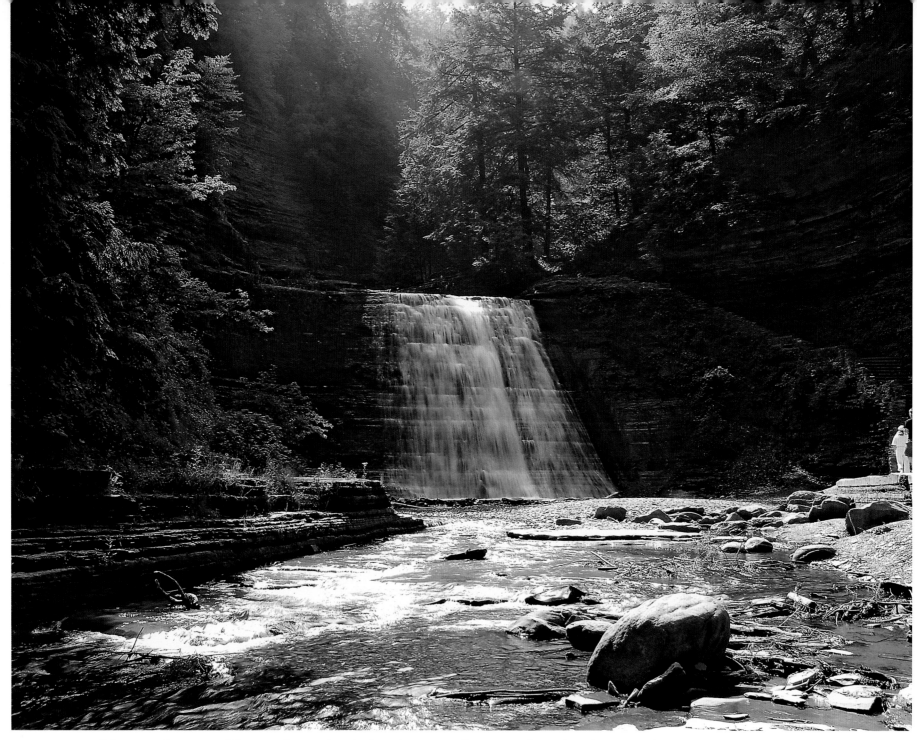

There are three waterfalls more than 20 feet high and many smaller ones at Stony Brook State Park.

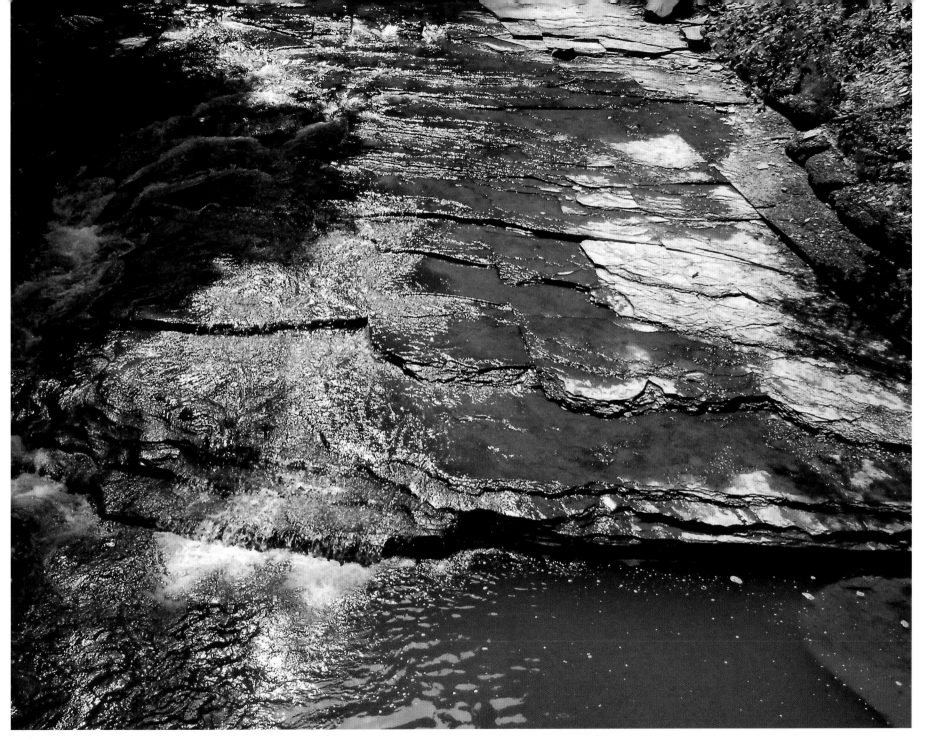

The stony brook itself as seen from one of the bridges that cross the gorge stream.

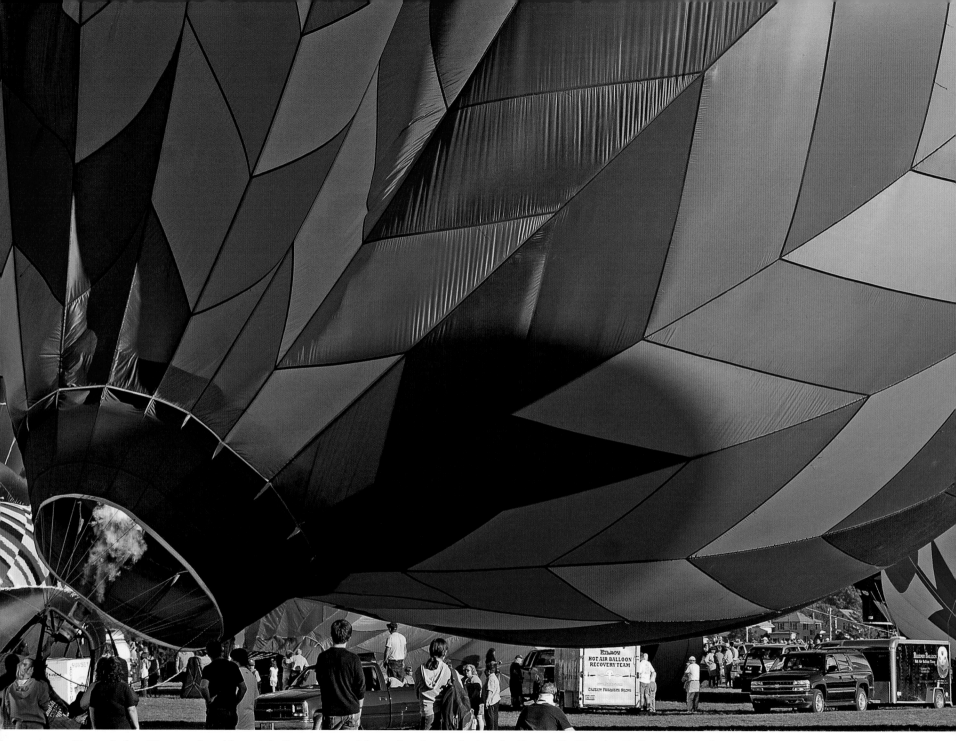

Every Labor Day weekend hot air balloons ascend from the airport during the Dansville Hot Air Balloon Festival.

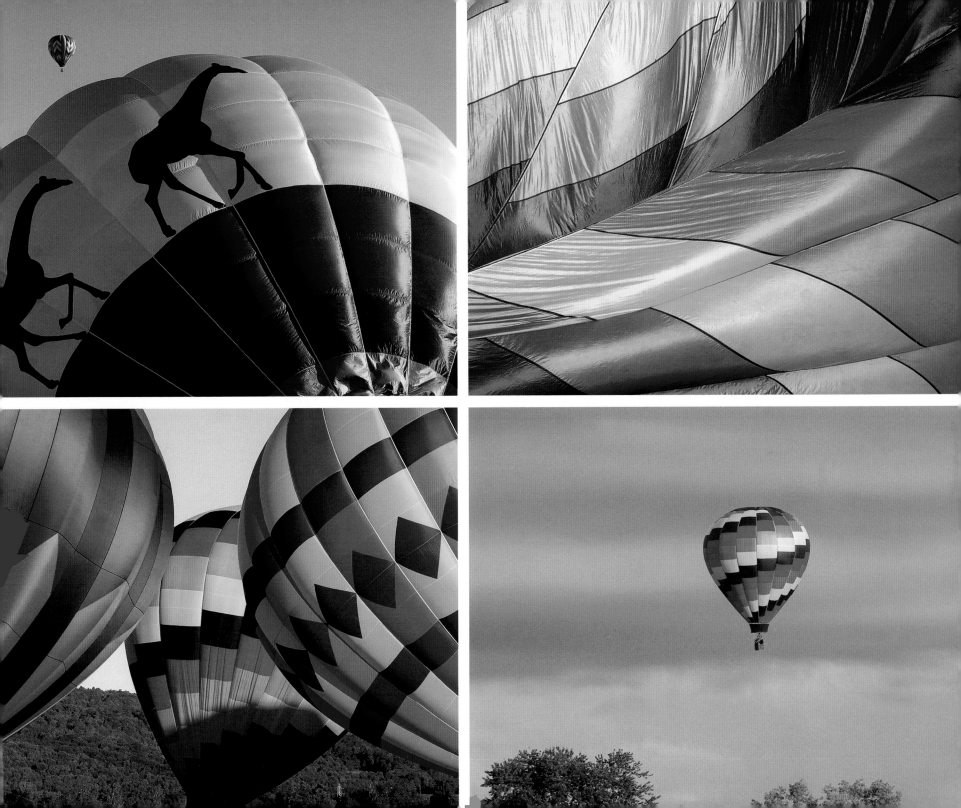

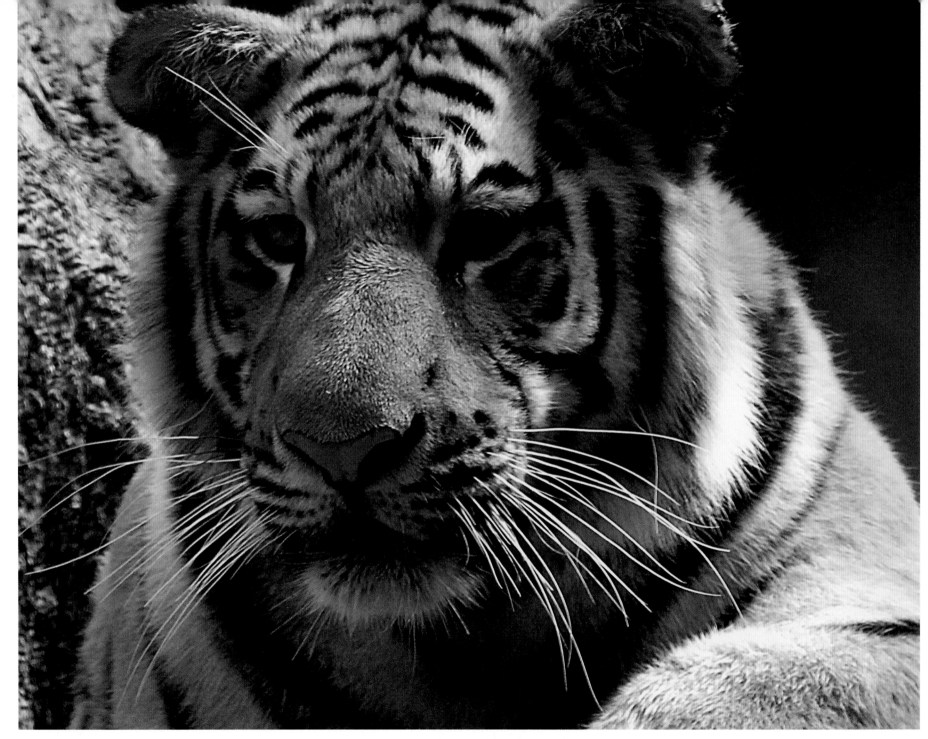

The Seneca Park Zoo houses hundreds of animals in the heart of Rochester. Five Siberian tigers live in a large steel enclosure. Utilizing a telescopic lens, I "eliminated" the steel bars in this photo, which almost makes me feel a little too close.

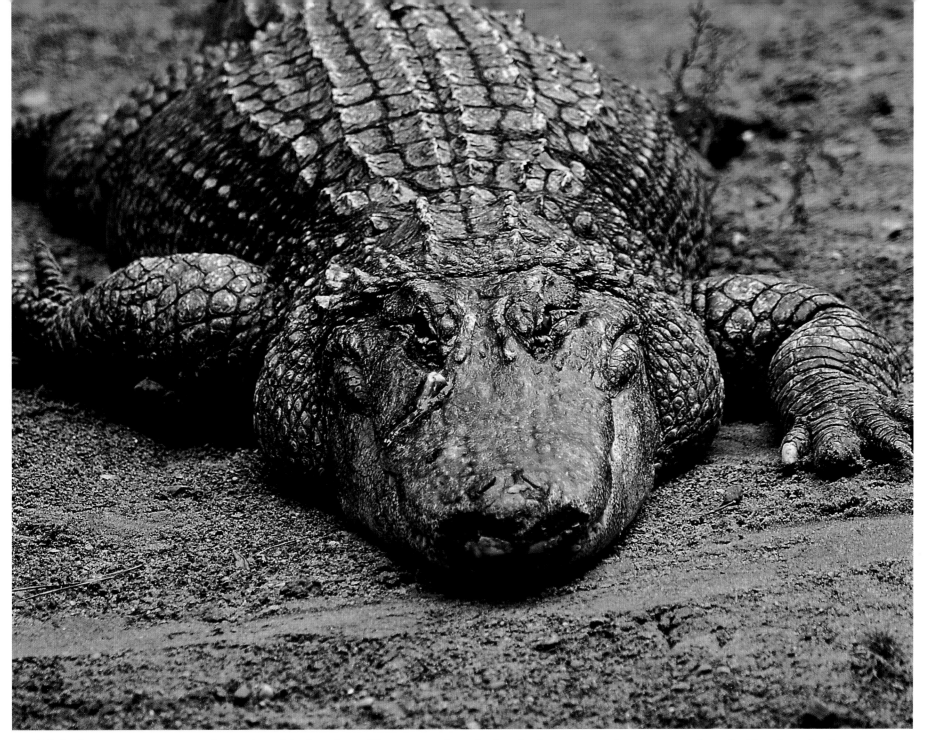

While the tigers were constantly moving, this American alligator stayed motionless for hours—seeming to move only at feeding time. In the wild, adult males may grow to 12 feet long and can live 30 to 35 years.

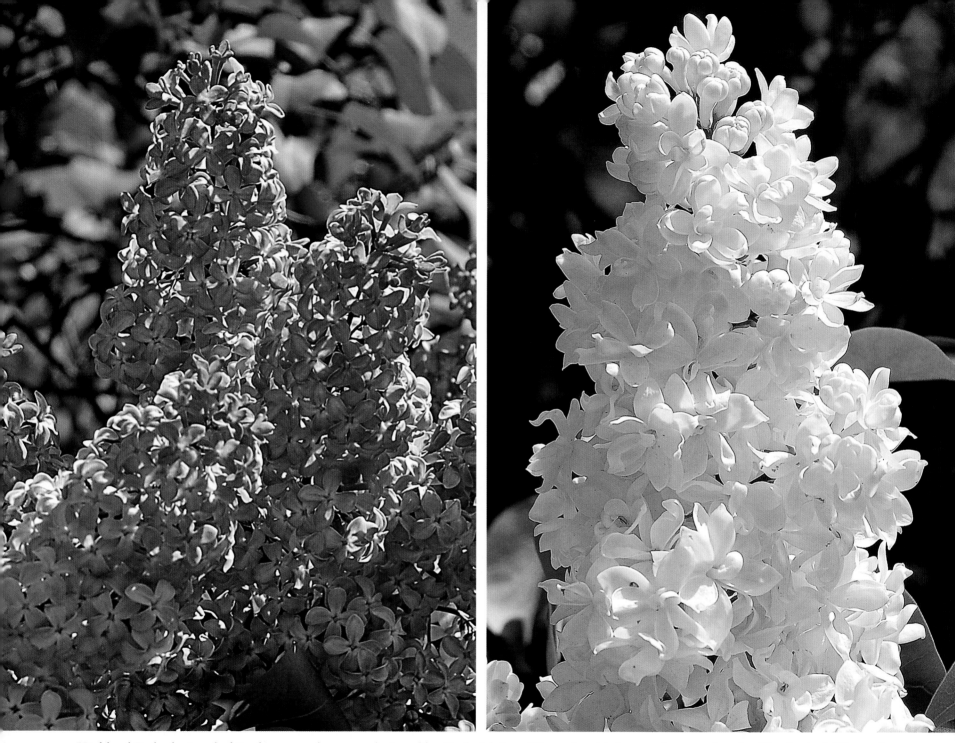

34 Highland Park, the jewel of Rochester gardens, was designed by Frederick Law Olmsted and is host to the annual spring lilac festival. The park contains more than 1,200 lilac shrubs, as well as azaleas, a Japanese maple collection, magnolias, and more than 600 varieties of rhododendrons.

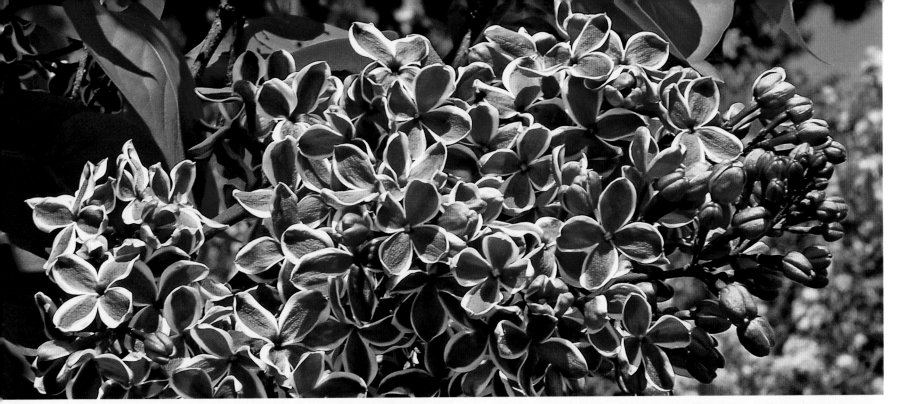

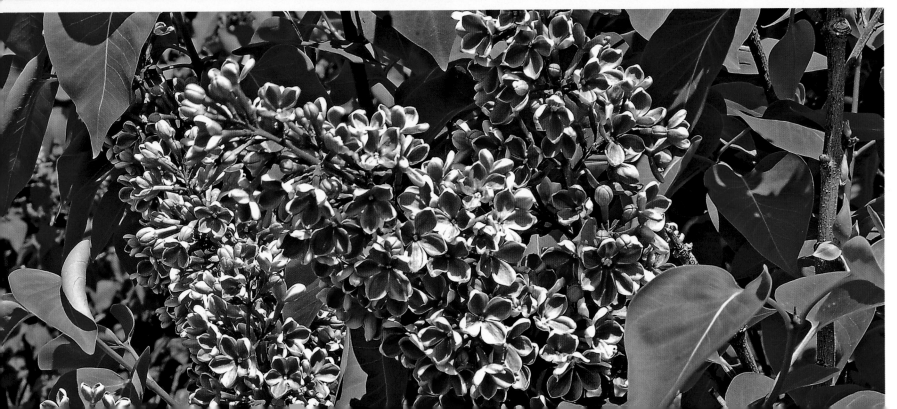

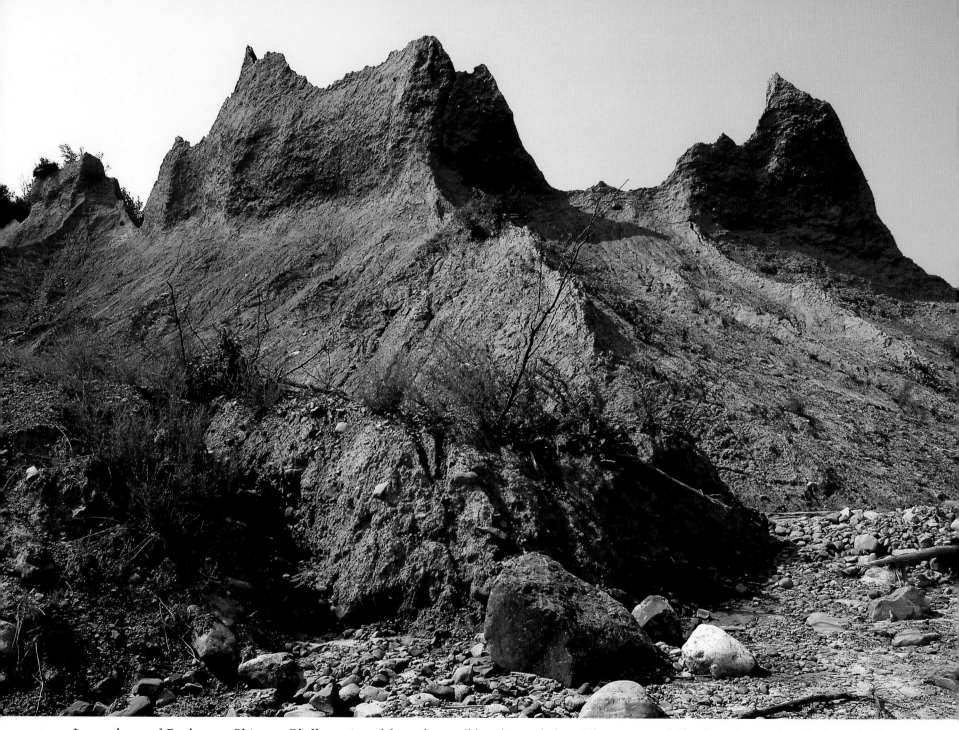

Located east of Rochester, Chimney Bluffs as viewed from the small beach area below. These narrow hills of sand, gravel, and silt are held together by clay and are constantly changed by wind, rain, and lake action.

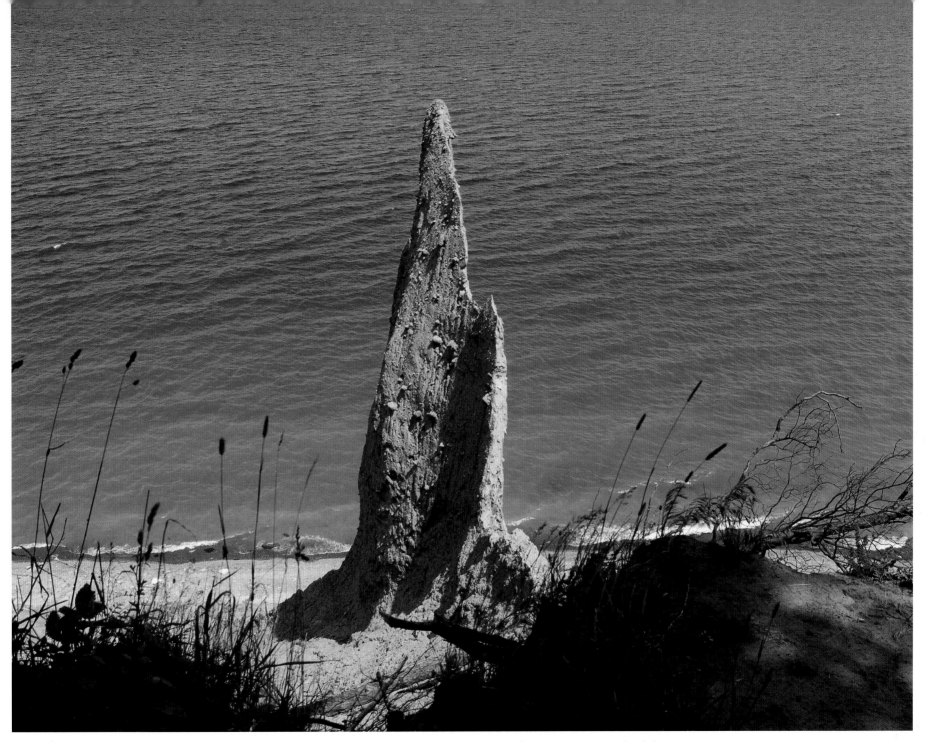

Chimney Bluffs' spire-like formations as seen from the Cliff Trail with Lake Ontario forming a pristine backdrop.

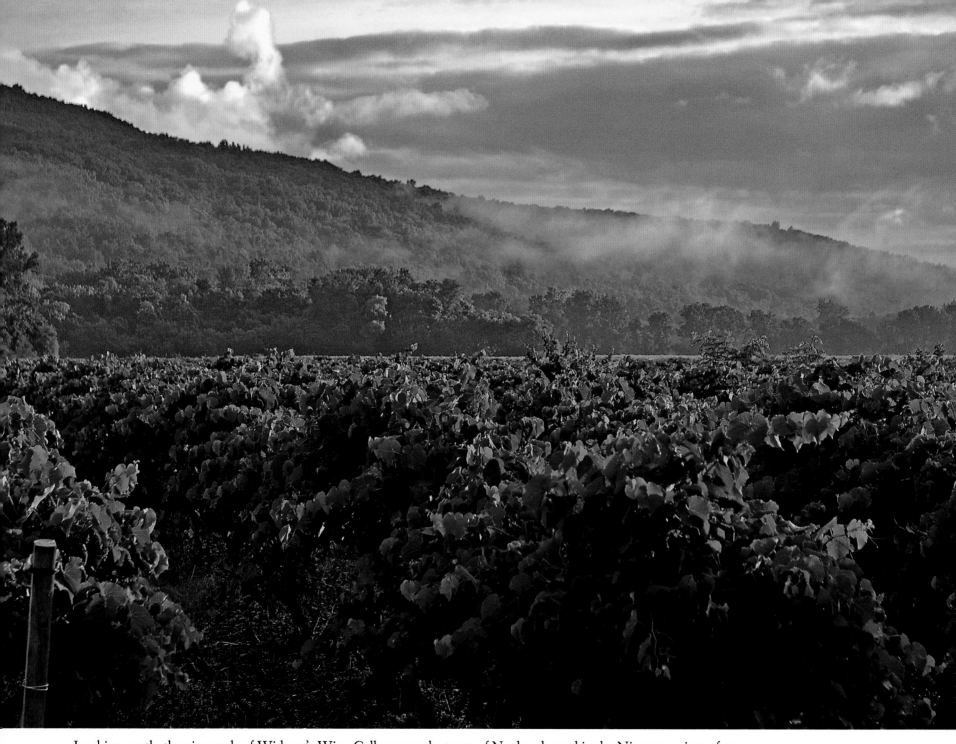

Looking north, the vineyards of Widmer's Wine Cellars near the town of Naples abound in the Niagara variety of grapes.

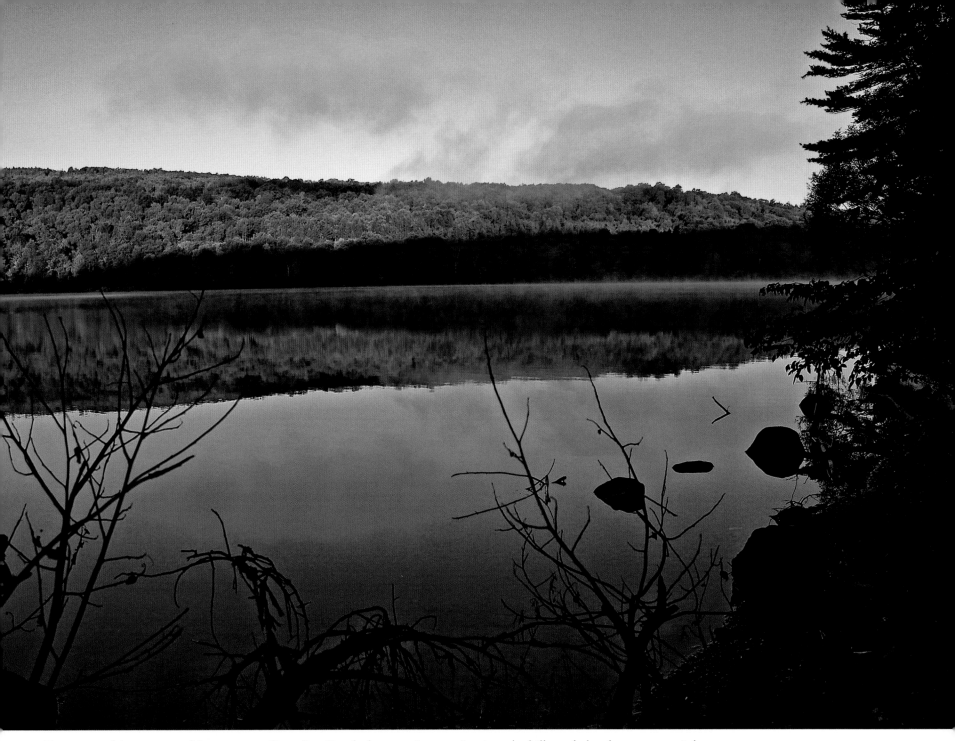

From one of the many parking areas on Canadice Road, the morning sunrise tints the hills and clouds a creamy pink.

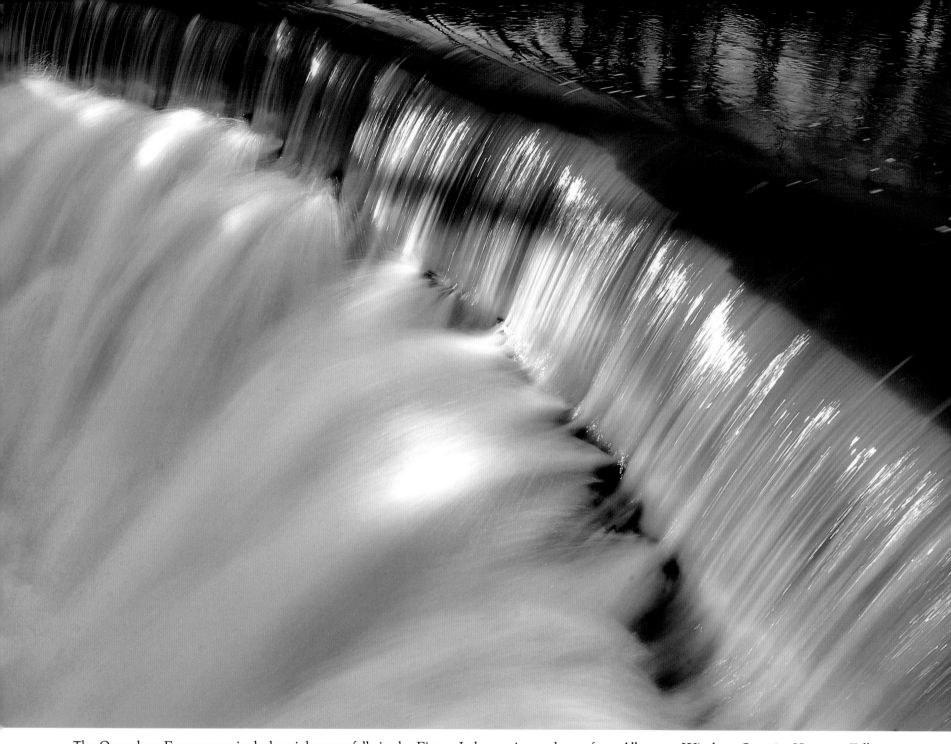

The Onondaga Escarpment includes eight waterfalls in the Finger Lakes region and runs from Albany to Windsor, Ontario. Honeoye Falls, shown here, is about 20 feet high.

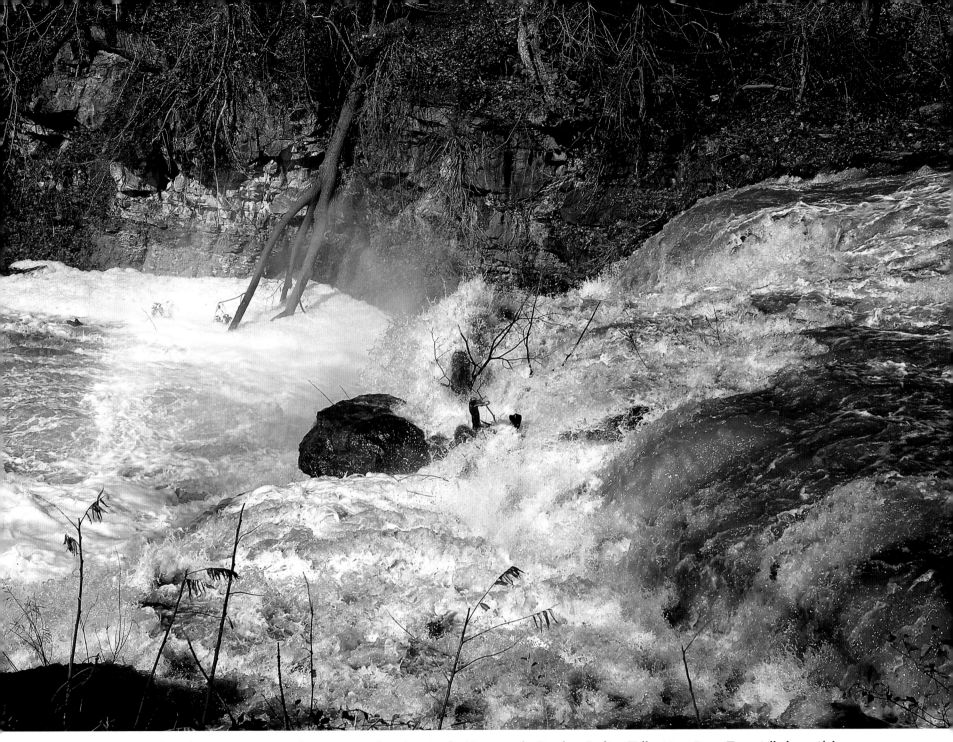

I observed this partial rainbow as water cascades over a 20-foot drop in the Tonawanda Creek at Indian Falls. *Next Page:* Especially beautiful near sunrise, Buttermilk Falls at LeRoy descends 60 feet on the Oatka Creek.

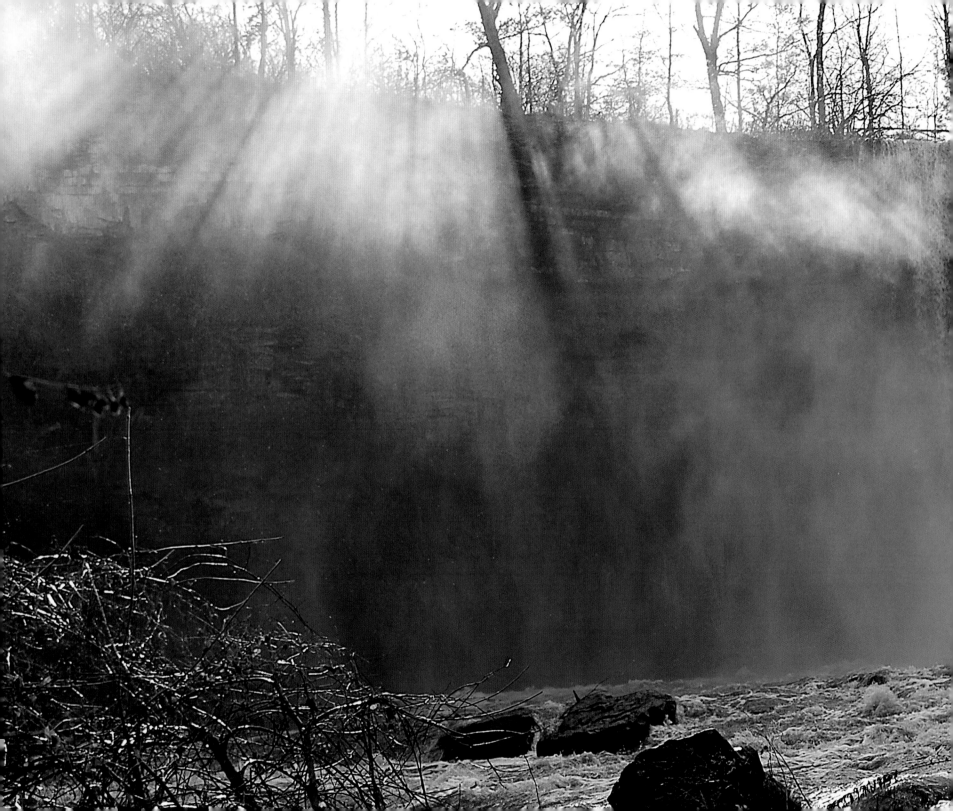

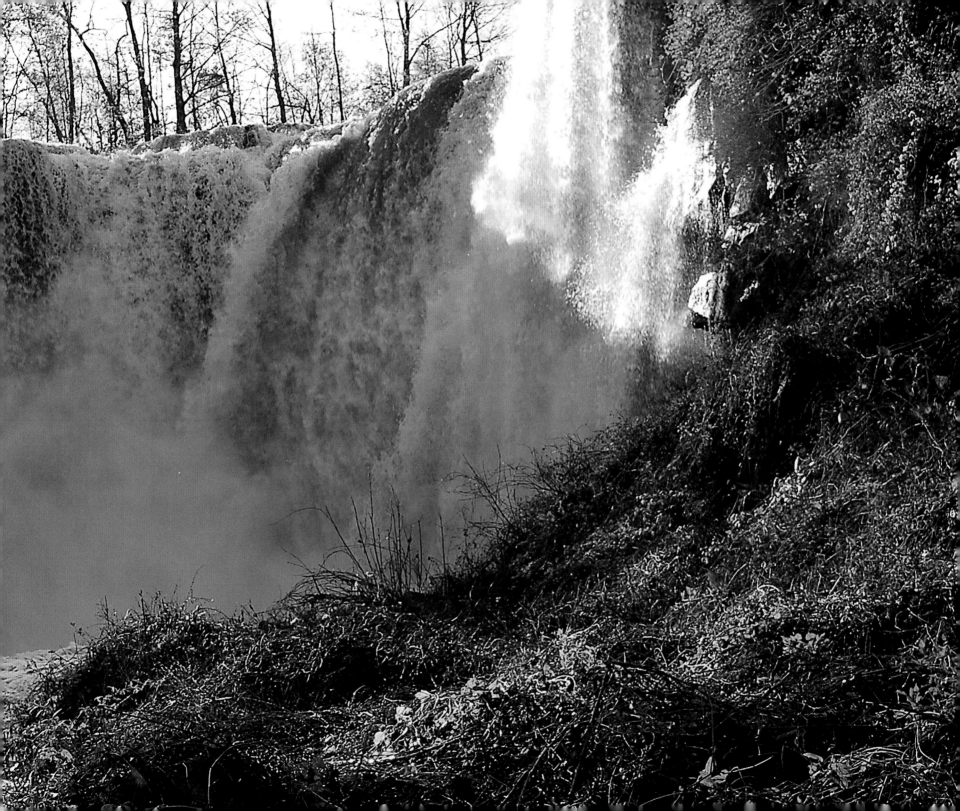

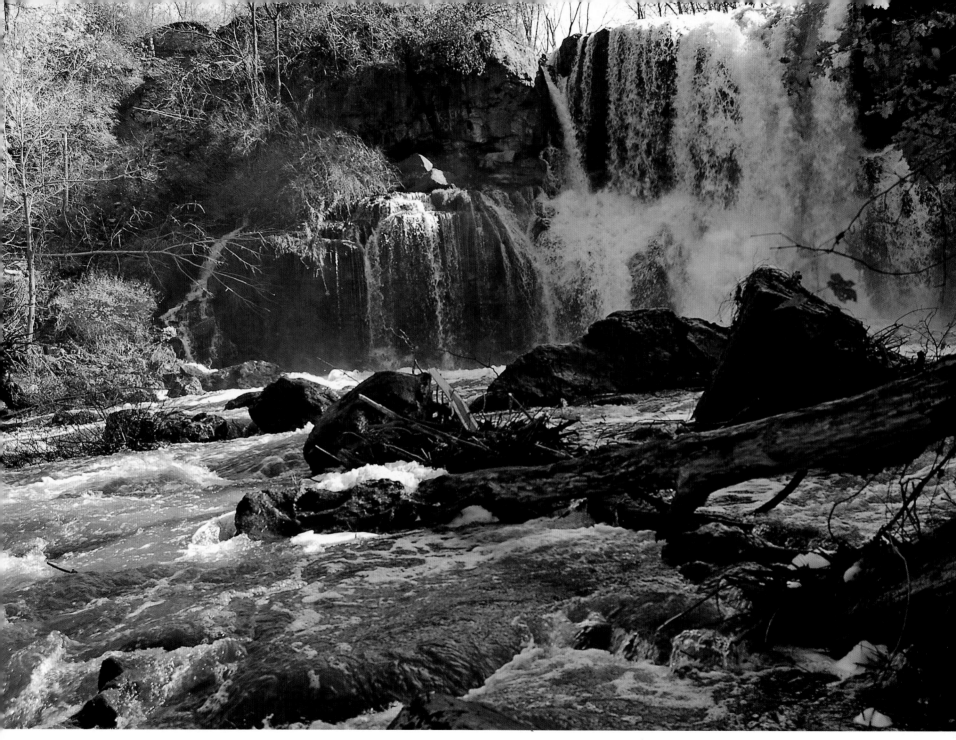

Akron Falls is usually dry in summer but can be spectacular after a heavy rain. There are two beautiful waterfalls in Akron Falls County Park—
Upper and Lower falls. Both flow from Murder Creek in the village of Akron.

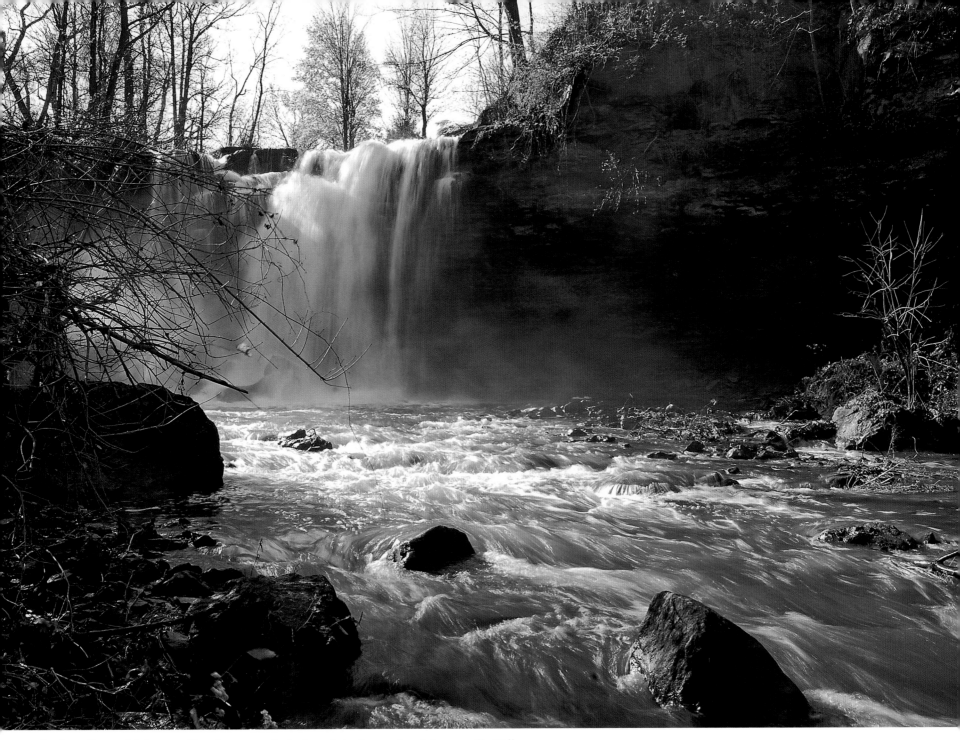

In the village of Morganville, along a secluded road, is the 27-foot Morganville Falls.

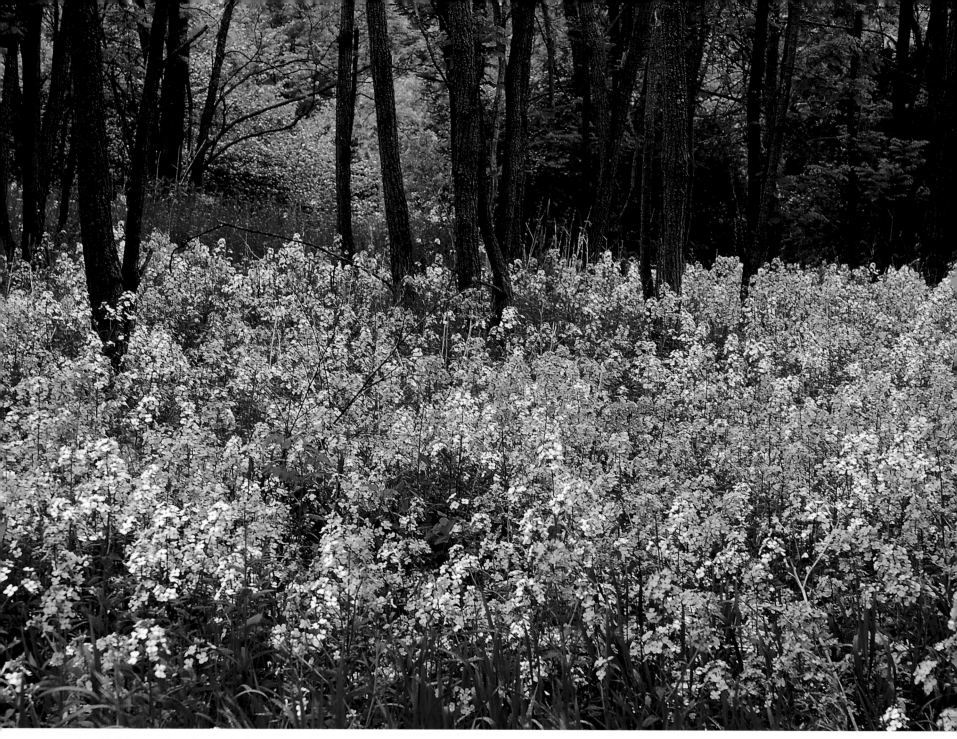

A colorful Bristol Hills roadside view with purple and white dame's rocket intermixed with hardwood trees.

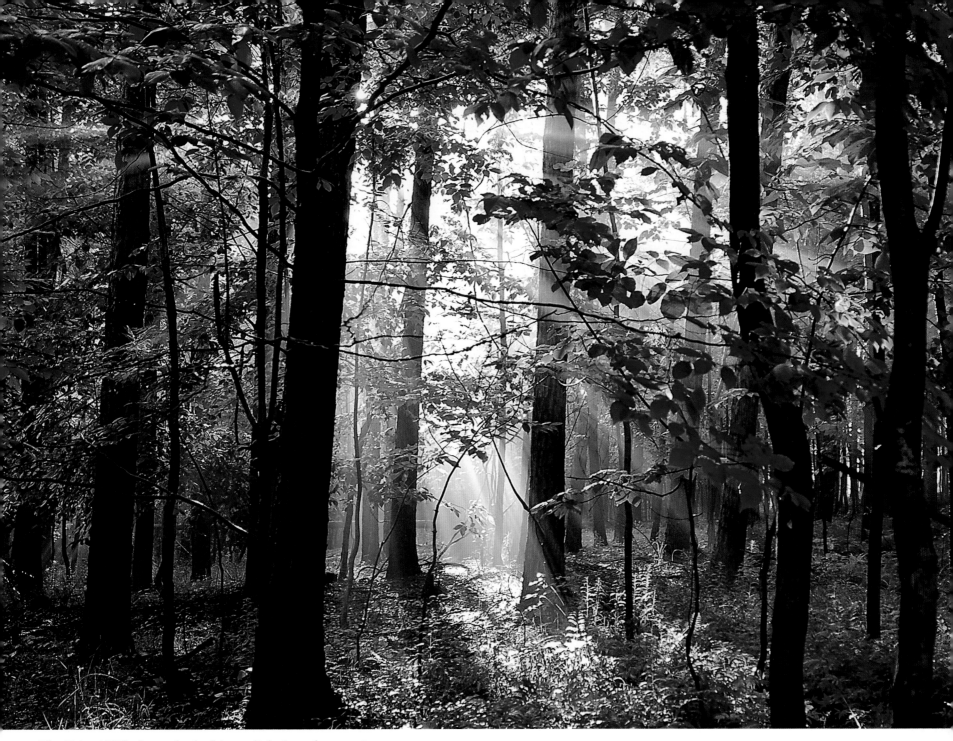

The Bristol Hills forest, bathed in sunlight just after a major storm.

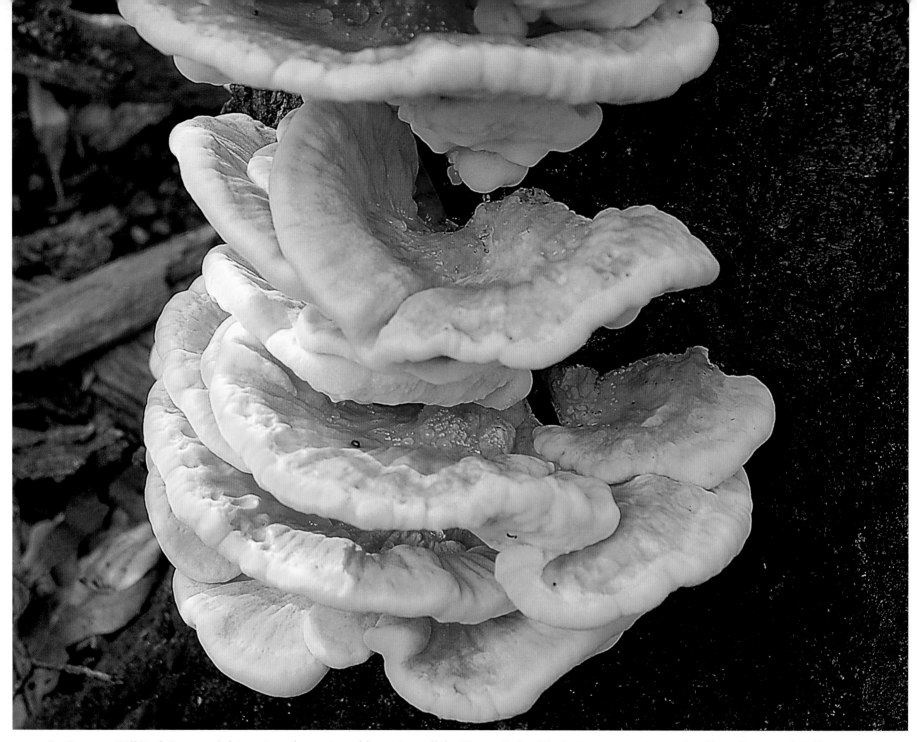

In Gannett Hill Park I spotted this unique formation of fungi just off the Finger Lakes Trail. *Next Page:* A casual walk in the Bristol Hills reveals a mist-covered pond near sunrise.

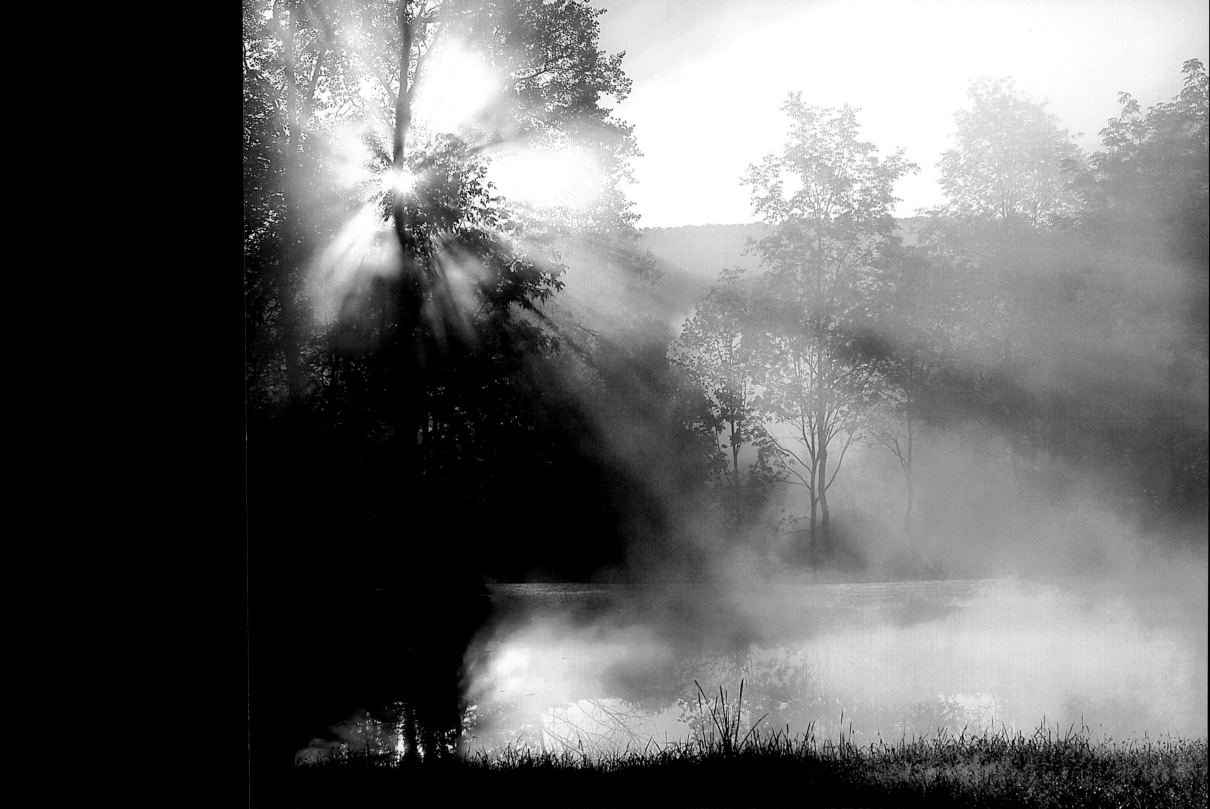

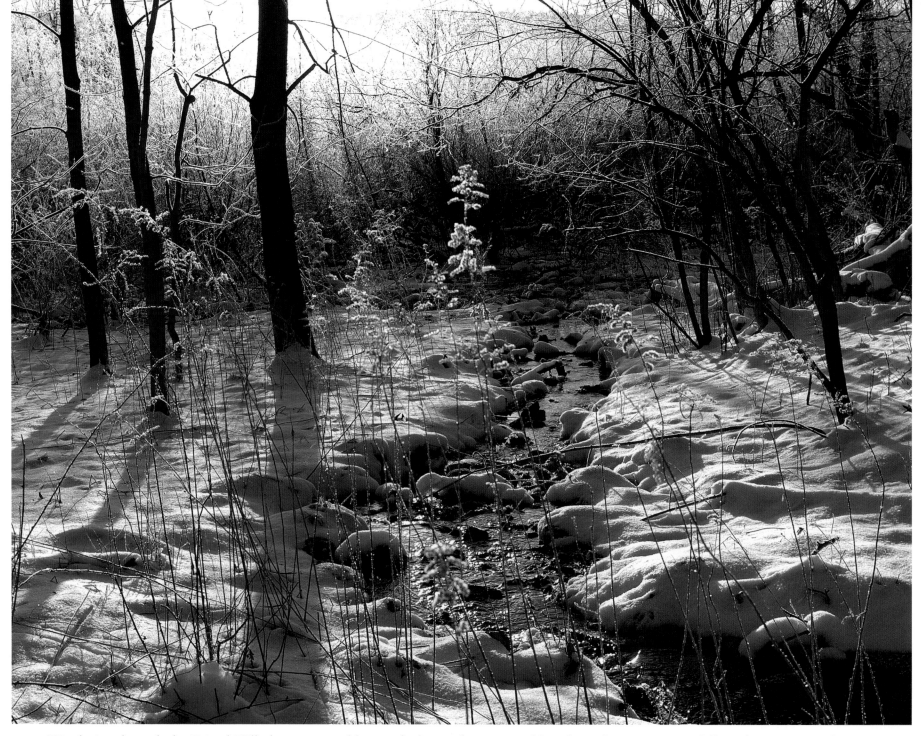

Wandering through the Bristol Hills forest on a cold winter's day, with snow sparkling from the rising sun, I followed a stream until it
disappeared into the wetlands.

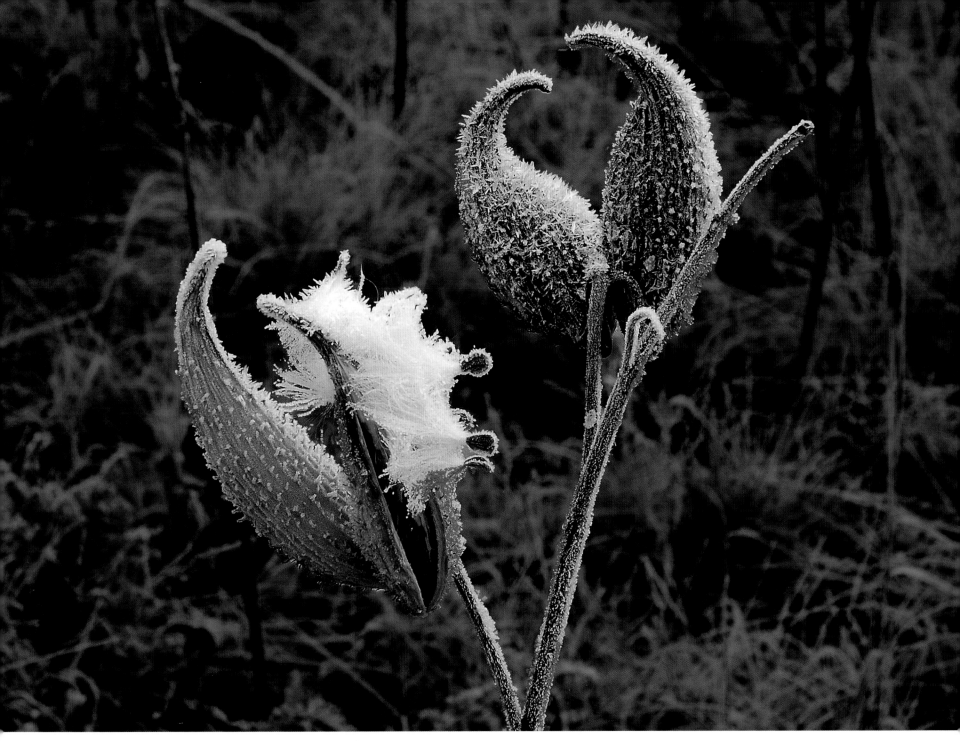

Early November frost coats a milkweed plant in the Conesus Inlet State Wildlife Management Area.

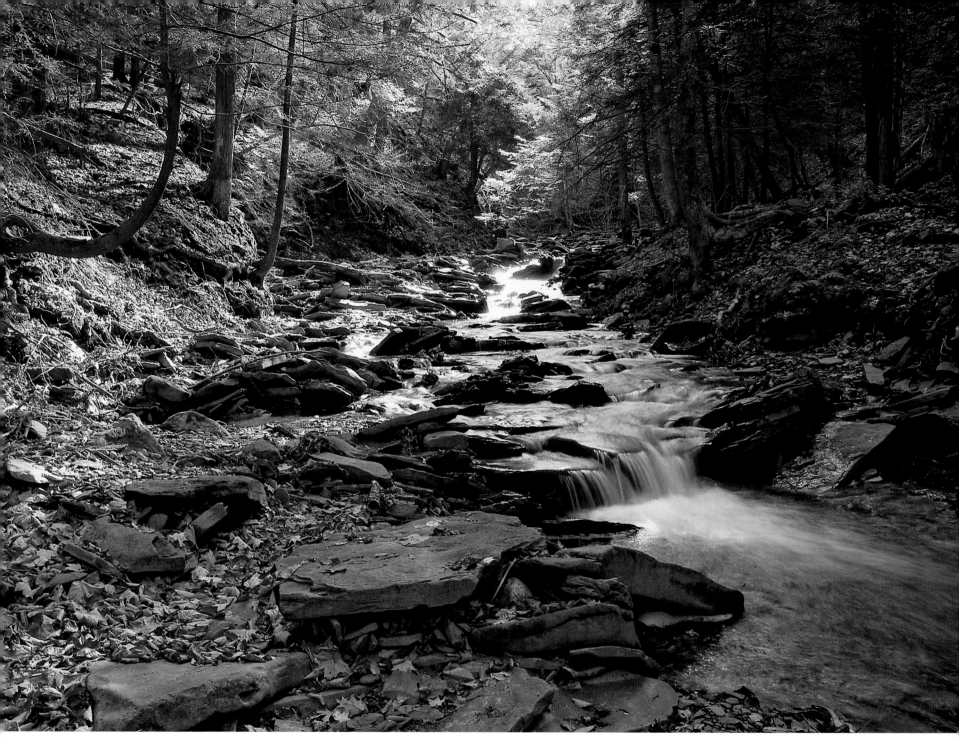

At Hi Tor Wildlife Management Area, the best way to see the tors—or high craggy hills—is to wade through the stream and carefully climb the many small, beautiful waterfalls. The ascent is quite slippery, but well worth the effort.

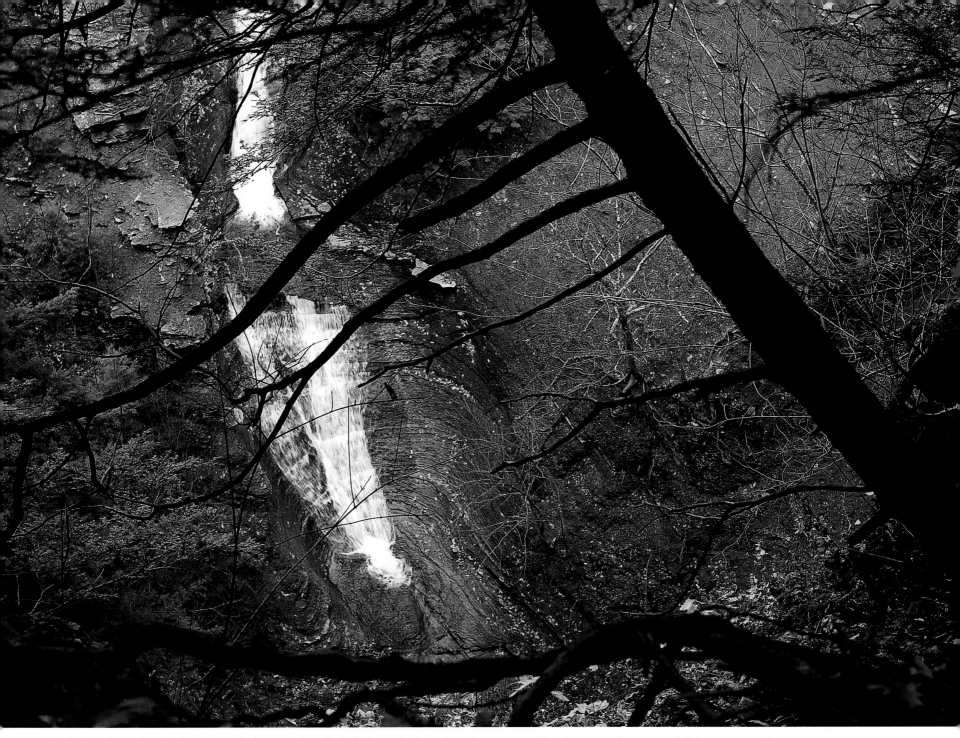

Climb less than a half mile up Hi Tor's steep Hatch Hill Rim Trail to view, from the cliff's edge, a 50-foot waterfall in an amphitheater setting.

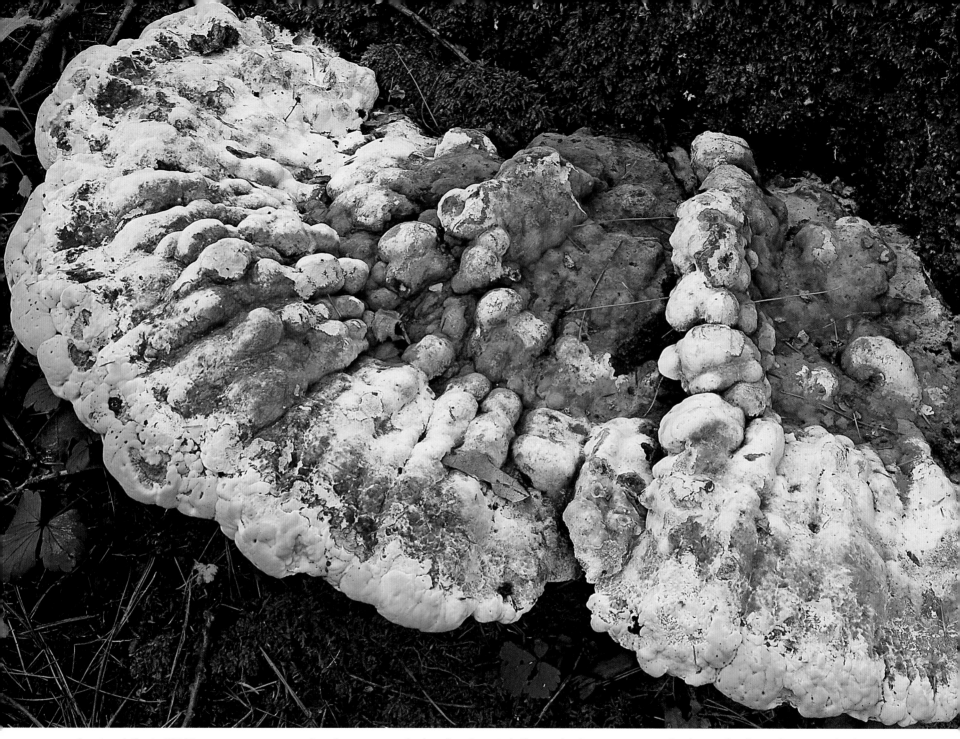

An easy hike in Hi Tor passes near a pond and grassy area before heading uphill into the forest. Deep in the forest this large fungus, which was more than 16 inches across and 6 inches deep, caught my attention.

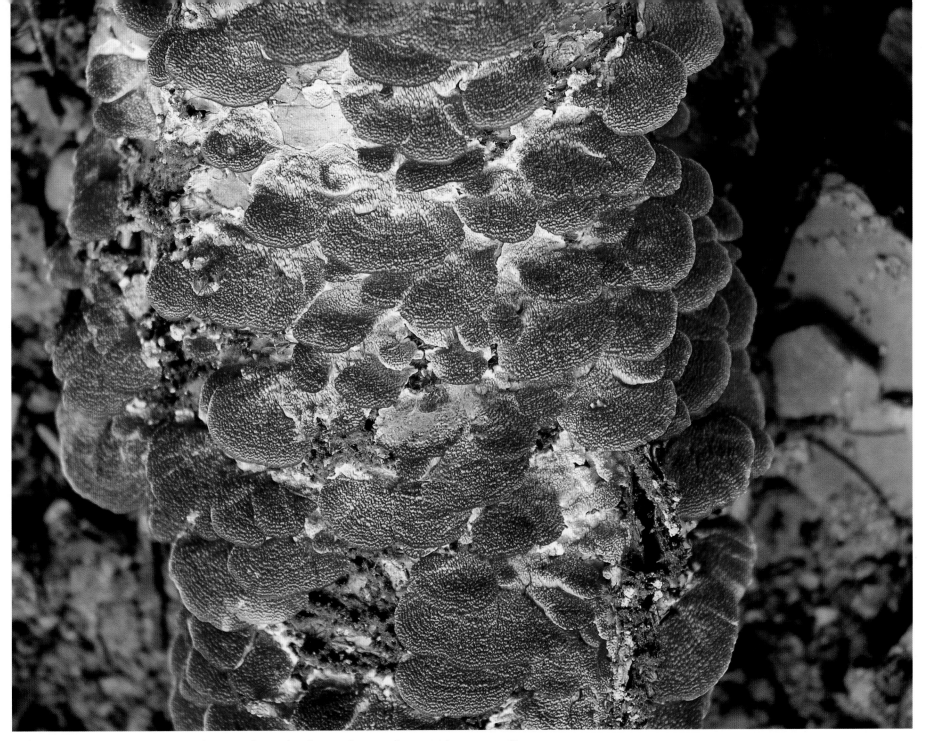

Clinging to a log near Hi Tor's gorge floor, this fungus has an almost iridescent quality.

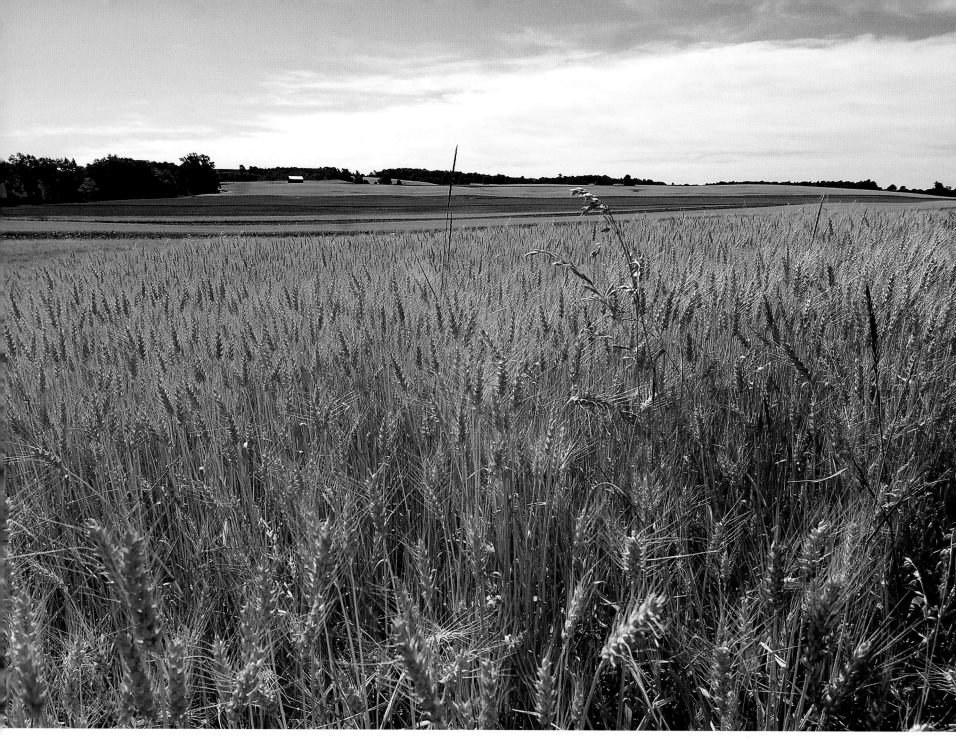

Wheat interspersed with grass and fertile land makes an interesting mosaic in the Rushville area, adjacent to Route 364.

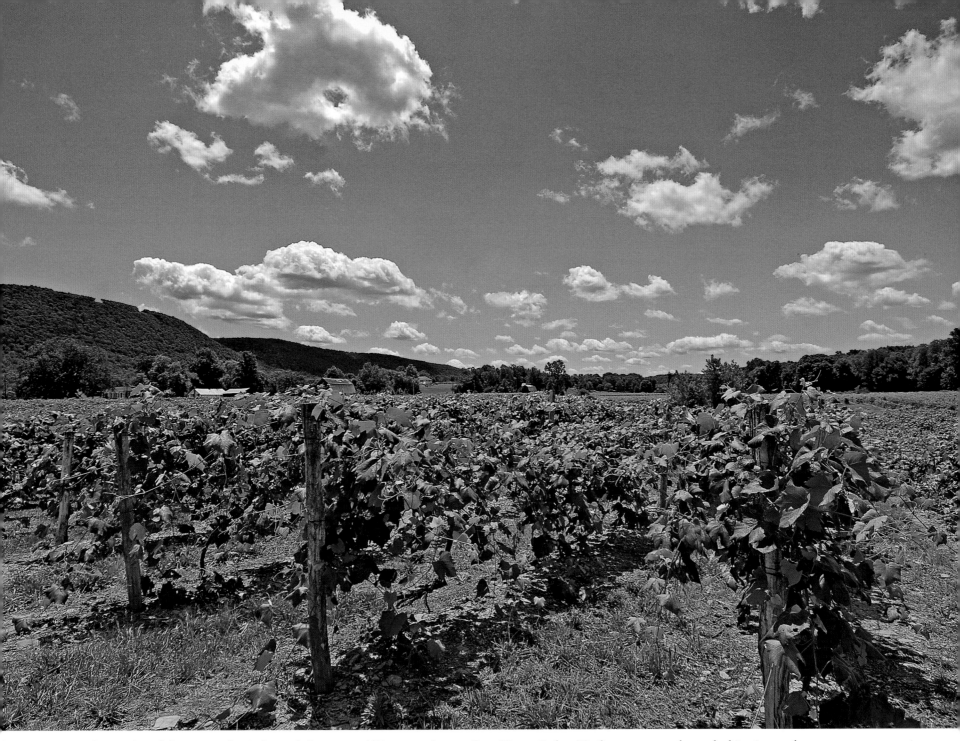

Vineyards are plentiful near Keuka Lake and the town of Hammondsport. One Finger Lakes Trail spur passes through this vineyard.

The longest foot trail in New York State is the Finger Lakes Trail. It runs from Allegany State Park to the Catskill Park with five branches for a total length of more than 880 miles.

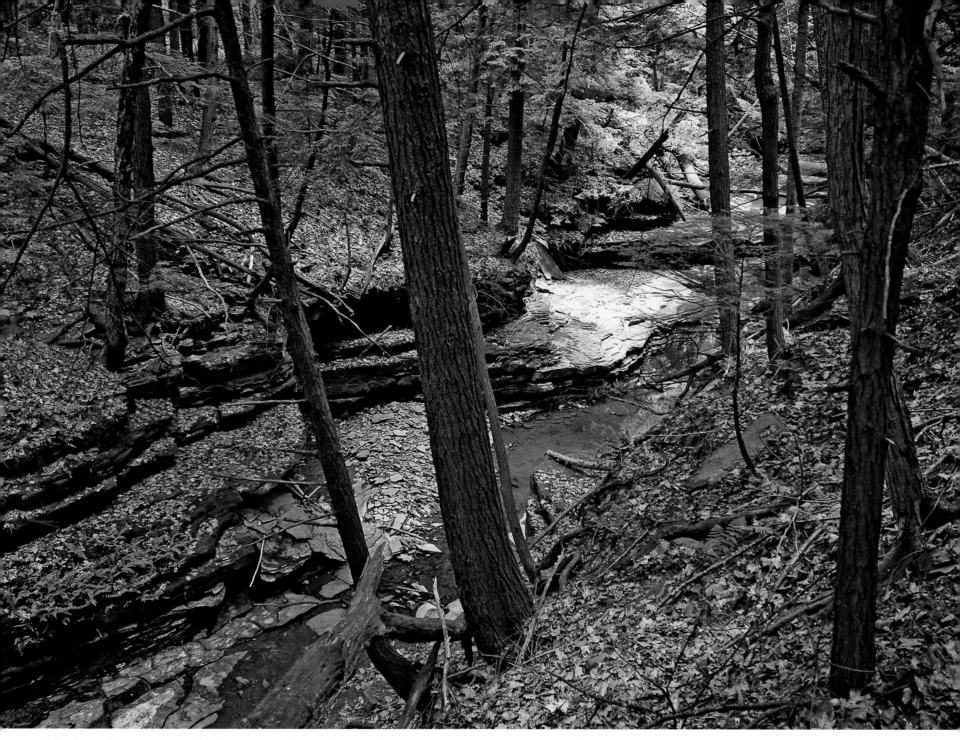

Off of Winding Stairs Road, the Finger Lakes Trail meanders through a quiet forest to the sound of a small brook.

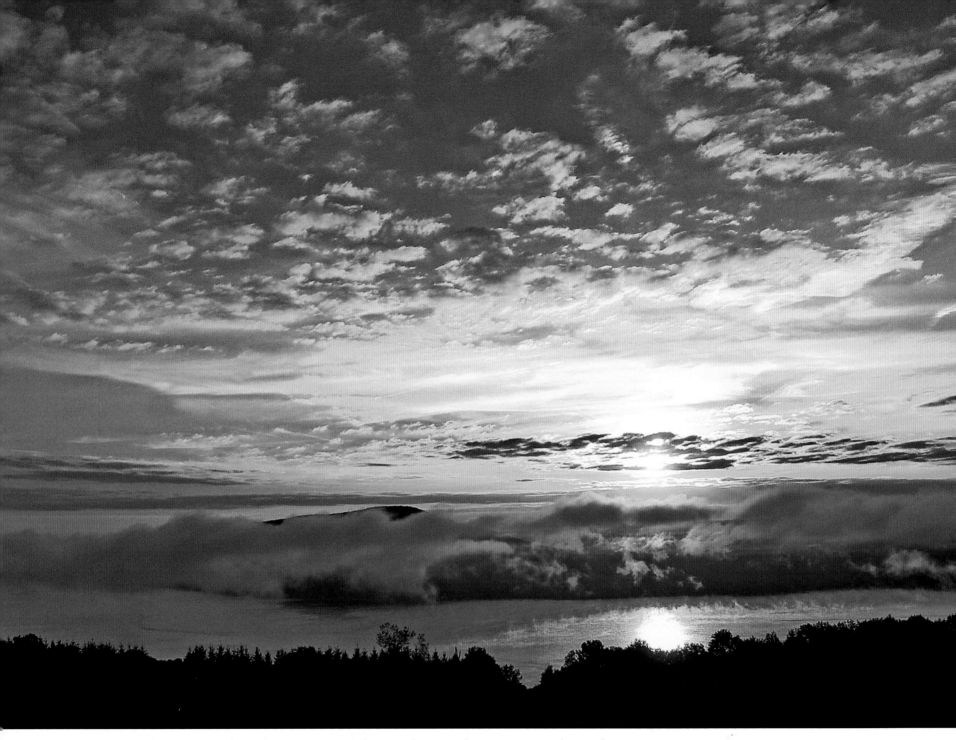

Early September mist rises from the warm waters of Canandaigua Lake as autumn makes its first appearance.

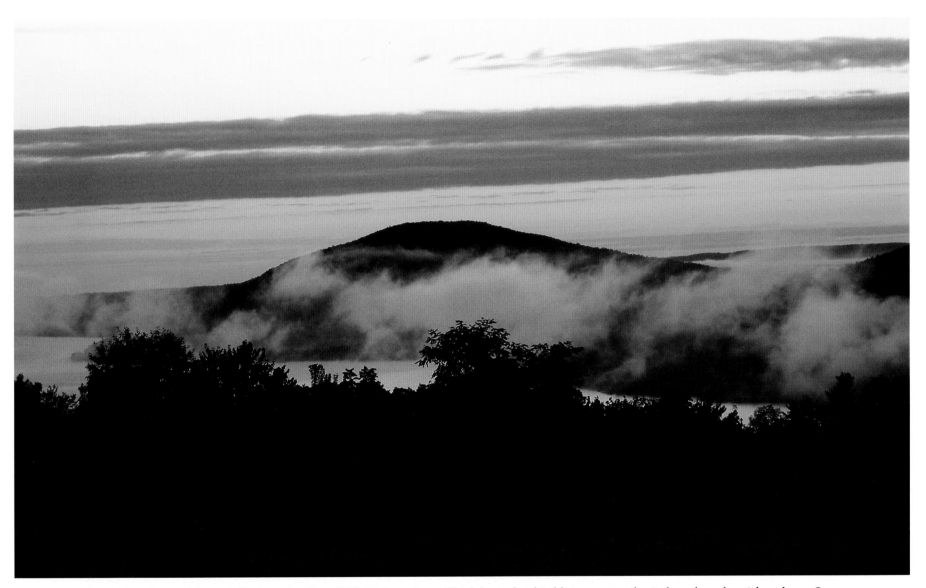

Fog marches down Canandaigua Lake hugging Bare Hill Unique Area. The lake is the third largest: 15 miles in length and 276 feet deep. Over half of the land surrounding the lake is forested, with one-third agricultural and the rest residential. The mountains gradually diminish to the north as they approach the town of Canandaigua—known to Native Americans as the "chosen spot."

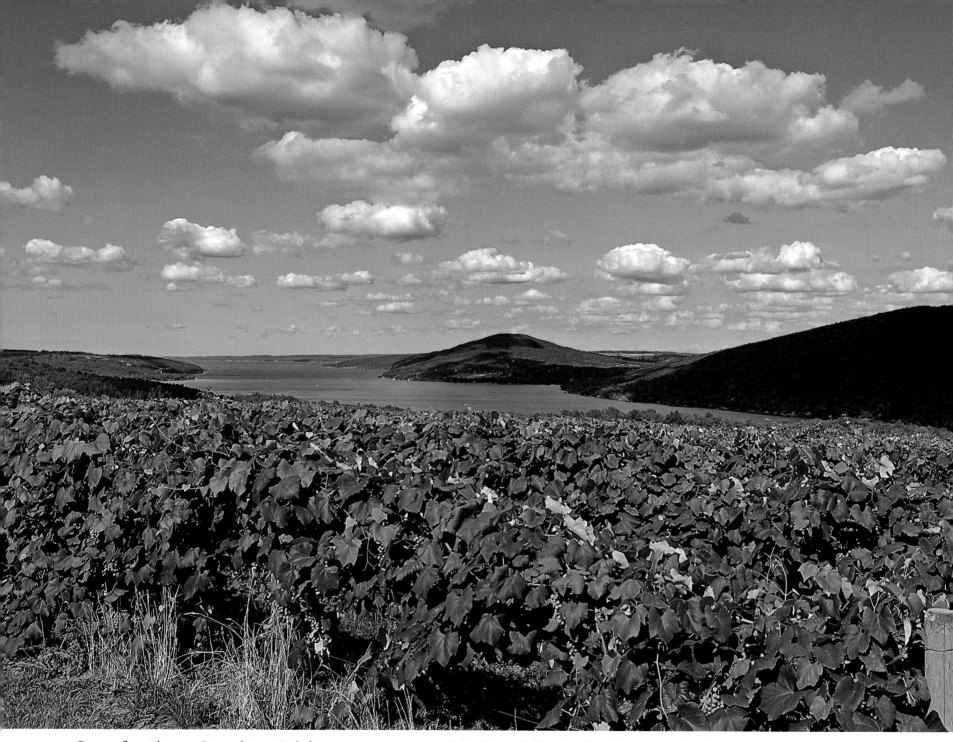

Grapes flourish near Canandaigua Lake's warmer temperatures. The closest hill is South Hill—or Nundawaho—where the Seneca people believe they first emerged into the world. Bare Hill is in the distance.

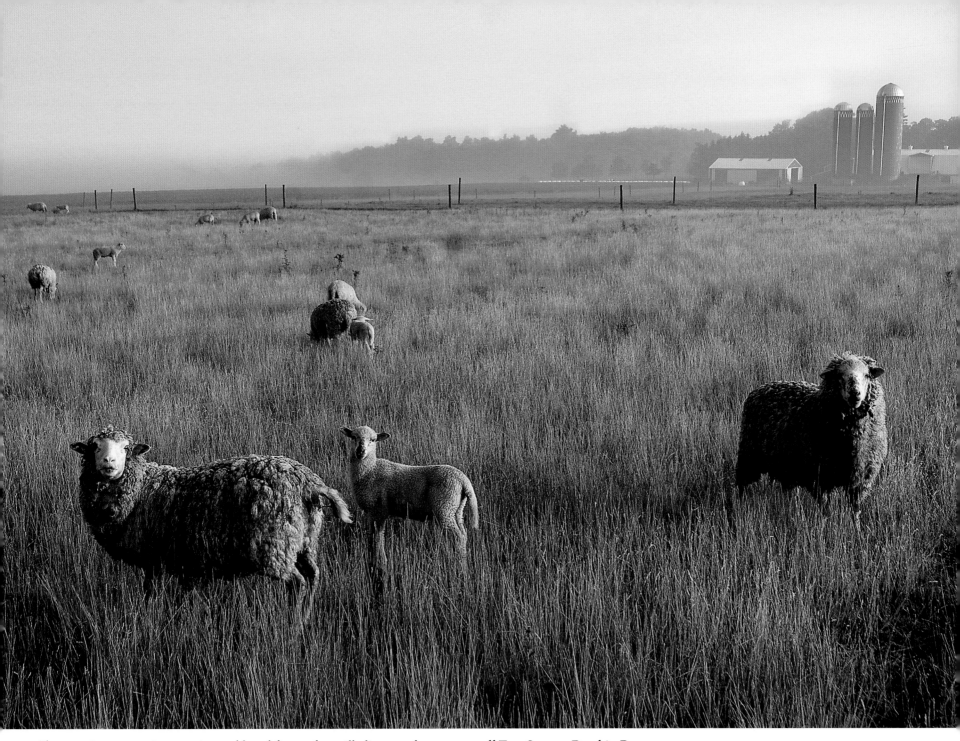

Sheep enjoy a morning sunrise and breakfast as fog still clings to the treetops off East Swamp Road in Potter.

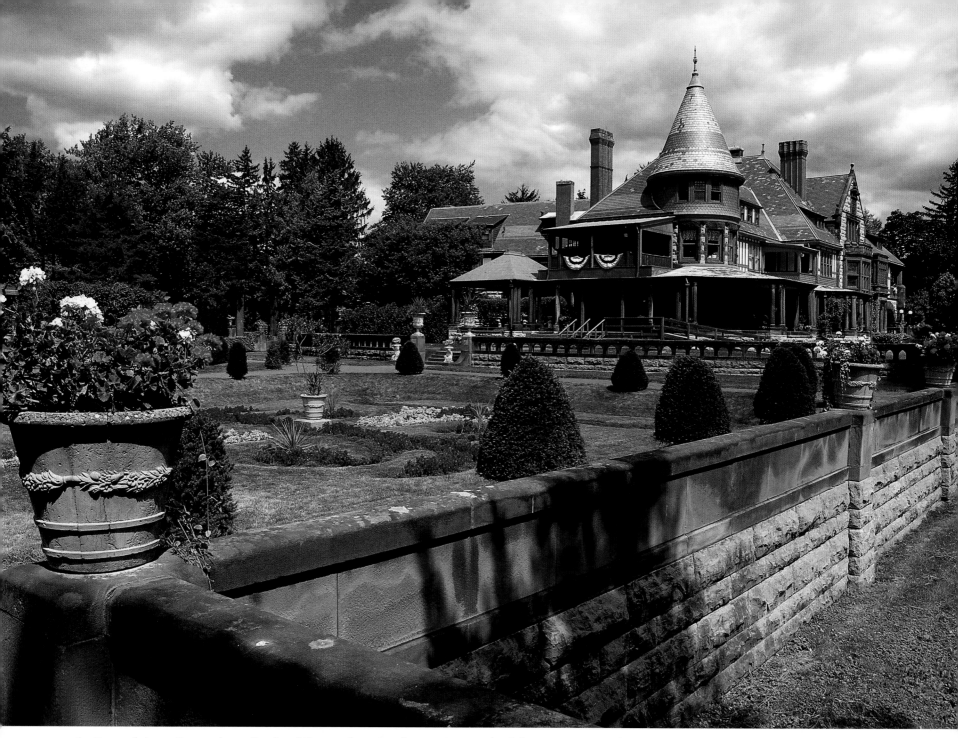

In Canandaigua, Sonnenberg Gardens' Queen Anne–style mansion was built between 1885 and 1888. Between 1903 and 1920, more than ten formal gardens were constructed. *Next Page:* The formal Italian Garden and the Old-Fashioned Garden.

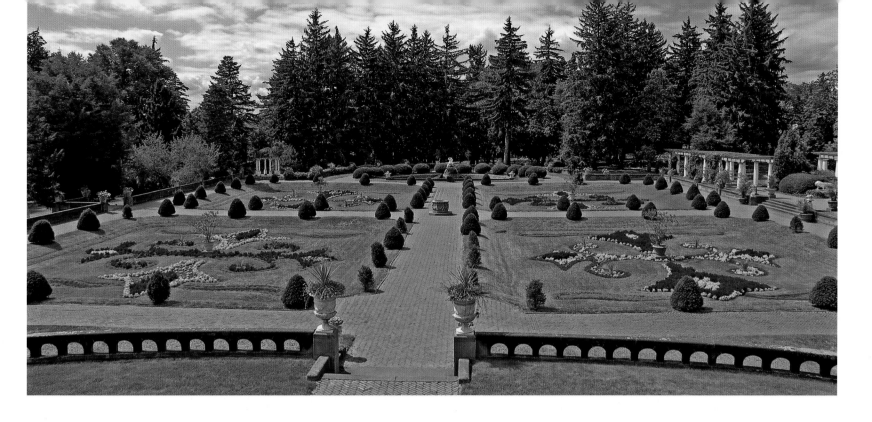

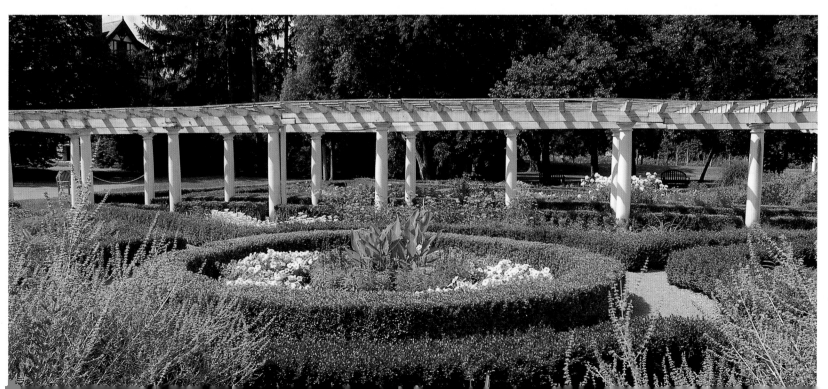

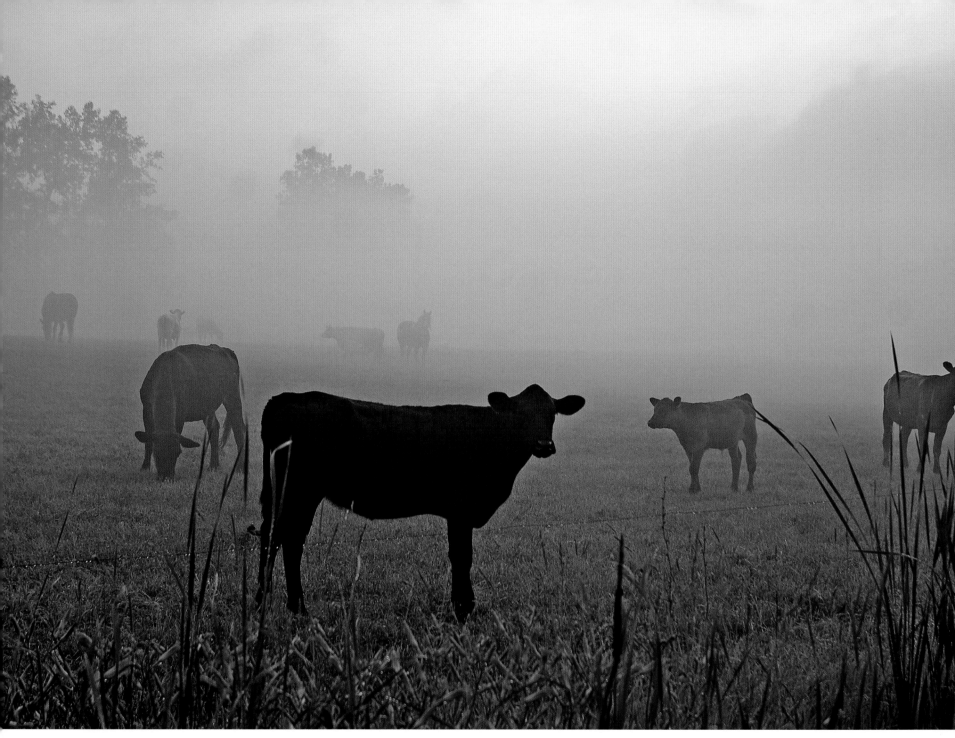

In Potter, a variety of reactions greeted my approach: one calf poses with his best side forward, another lets out a loud *moo*, a third keeps eating, and a fourth ignores me completely.

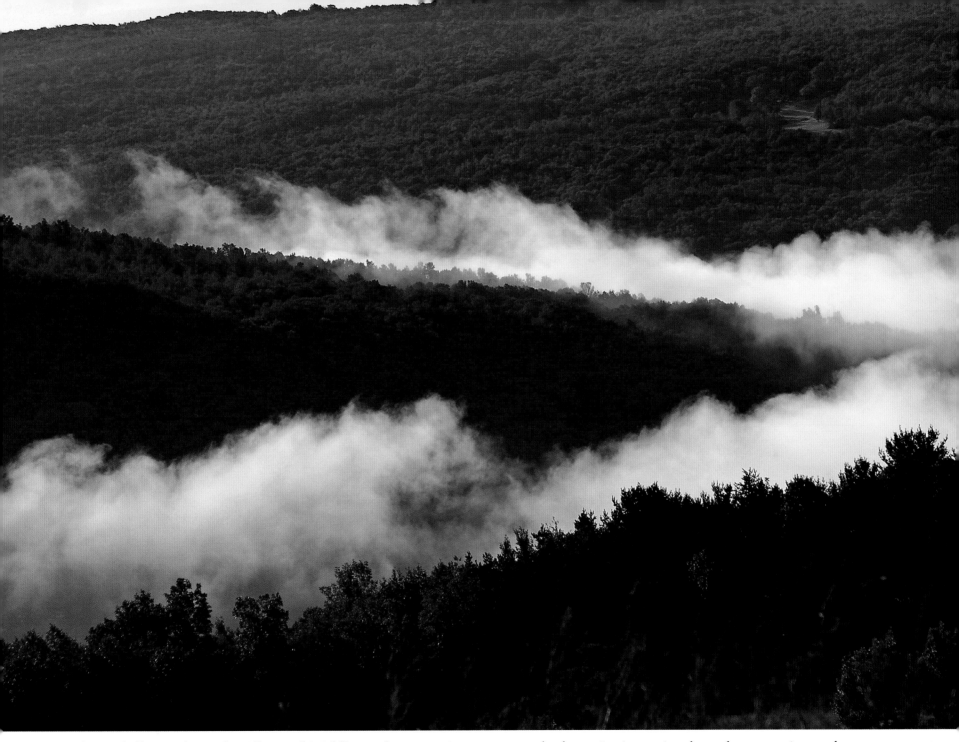

Toward Woodville, Naples, Italy Valley, and Middlesex, the mountain ranges steer the fog as it tries to rise above the mountaintops that surround the Canandaigua Lake outlet.

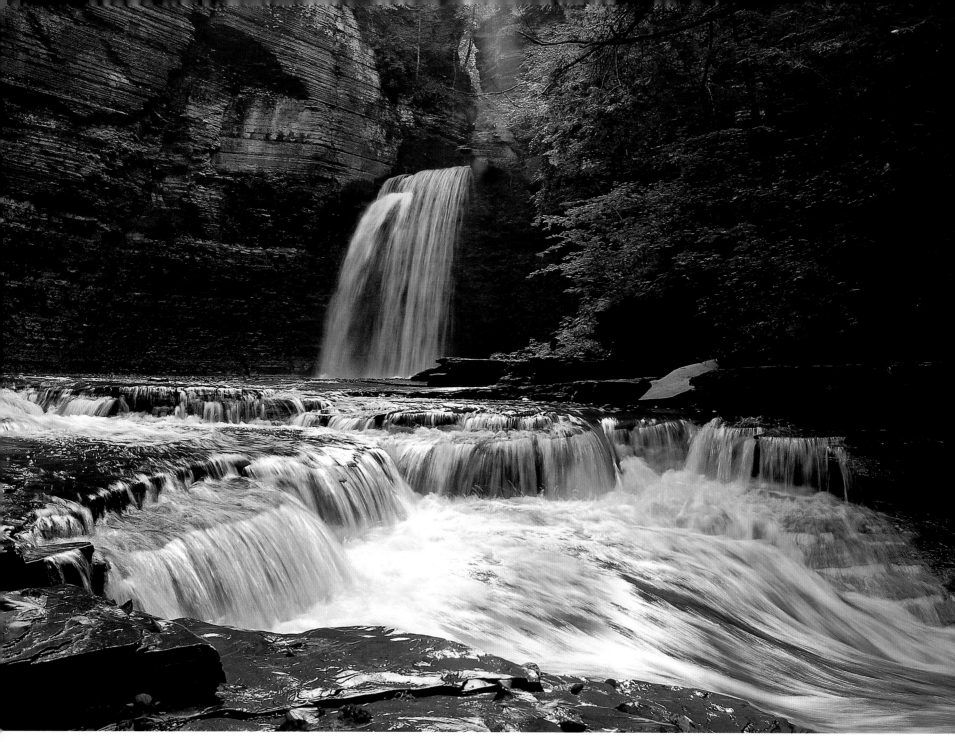

Eagle Cliff Falls on McClure Creek in Havana Glen Park is 41 feet high, with surrounding cliffs rising 160 feet above the base of the falls.

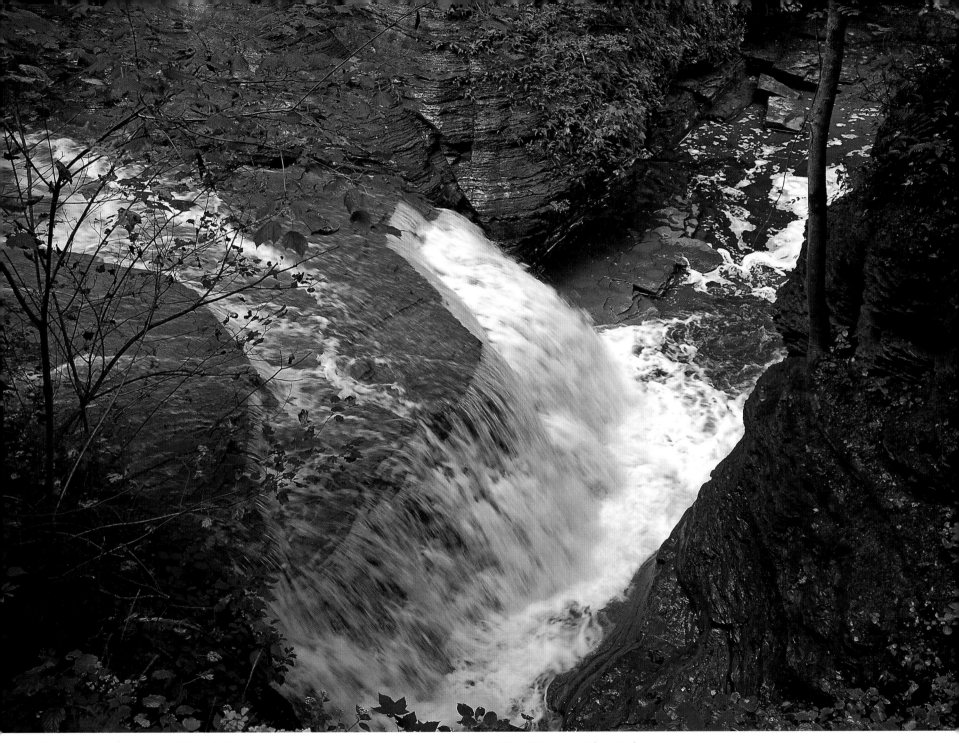

This picturesque waterfall is visible from the path that winds through the rock cliffs of Havana Glen Park.

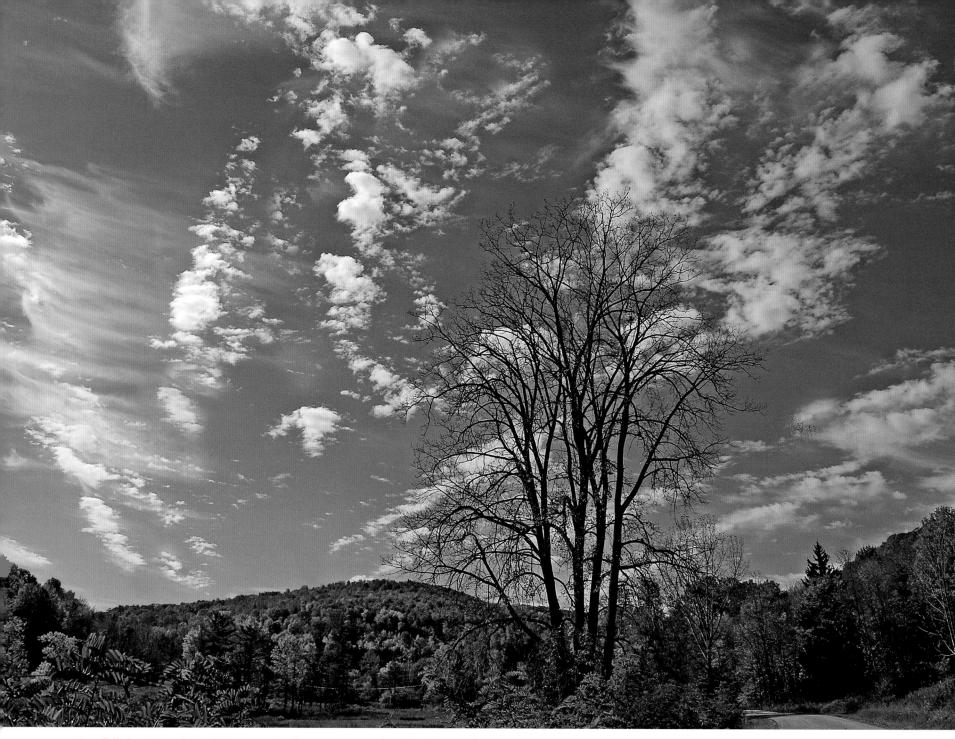

One fall day I traveled off the main highways to view the fall colors and interesting cloud formations.

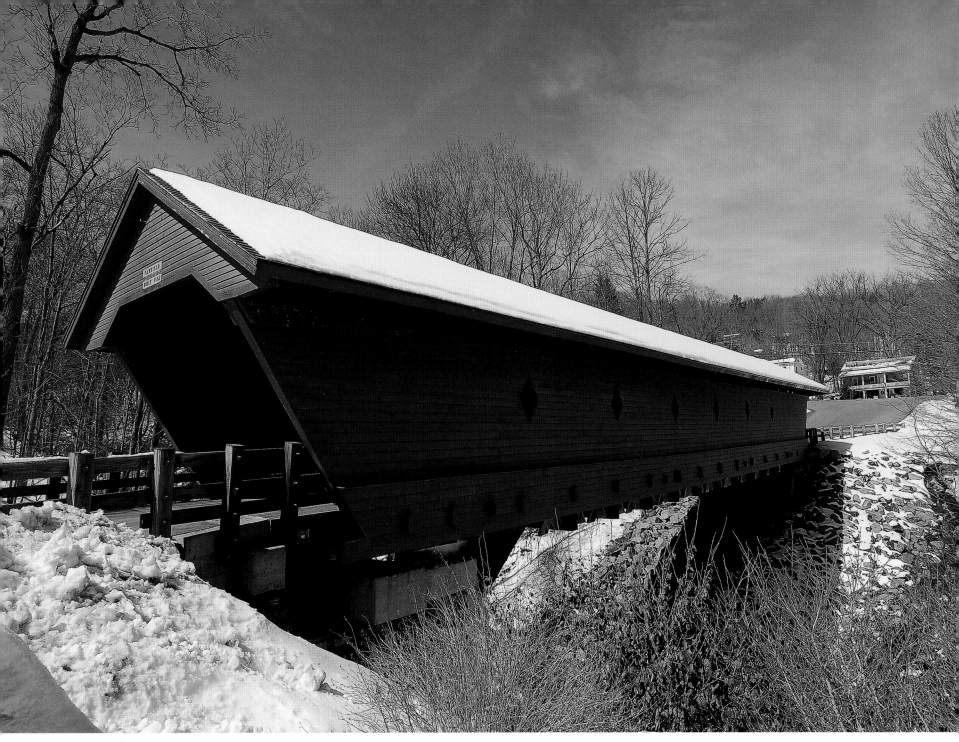

The Newfield covered bridge is one of 25 remaining in the state of New York. It was built in 1853, is 122 feet long, and crosses a branch of the Cayuga Inlet. The design is "town lattice truss," the most popular style because it utilized lighter timbers.

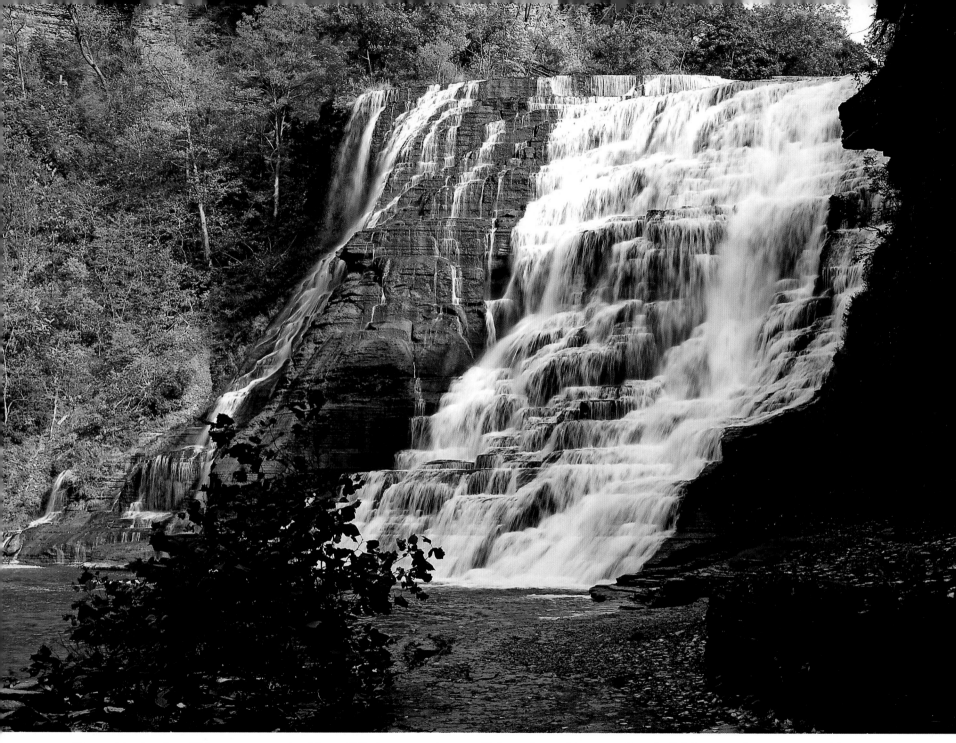

Situated in the city of Ithaca, spectacular Ithaca Falls is a one-minute walk from the parking area. People fish here, or they may sit and listen to the roar of the falls.

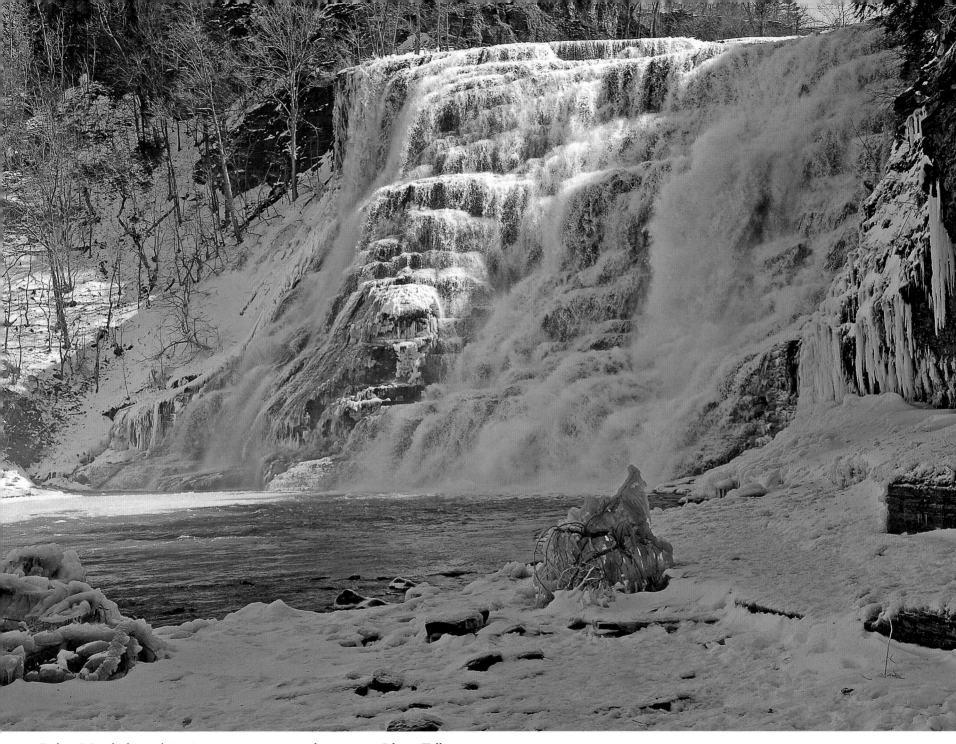

In late March the melting ice creates a torrent of water over Ithaca Falls.

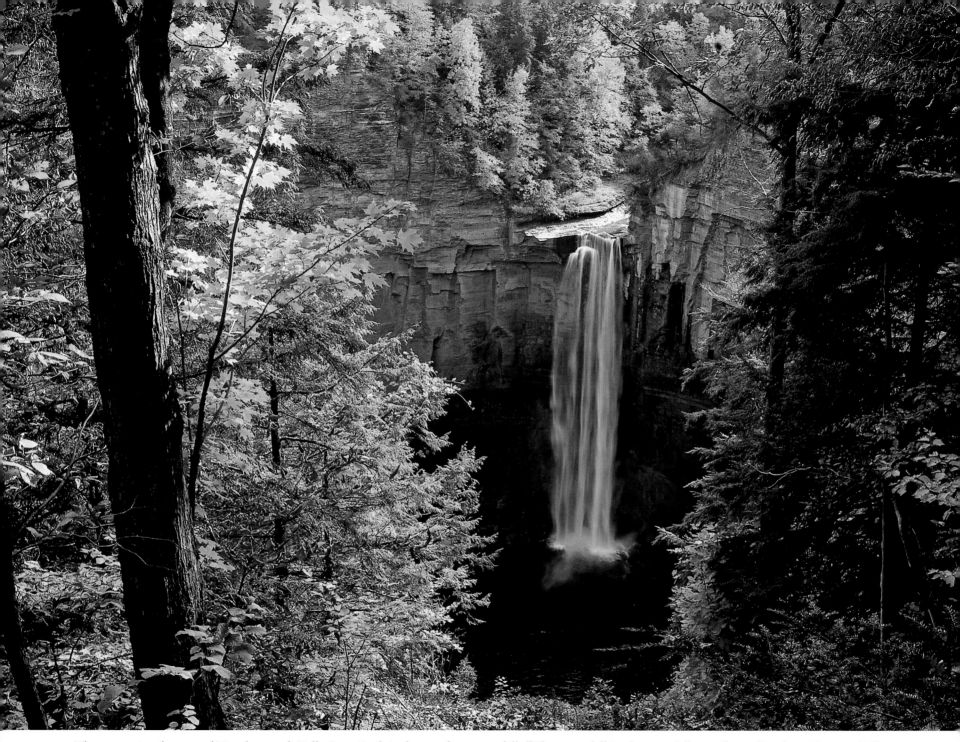

The crowning feature of Taughannock Falls State Park is the 215-foot waterfall. "The great fall in the woods" is 50 feet taller than Niagara Falls and the highest single-drop waterfall in the northeastern United States.

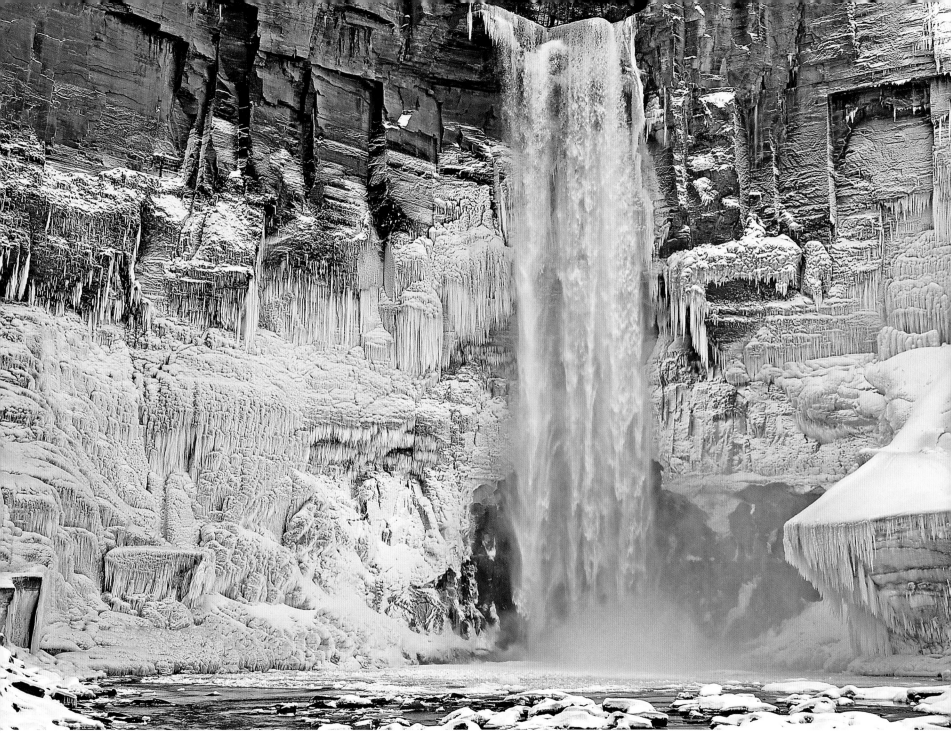

I walked the three-quarter-mile snow-packed Gorge Trail in mid-March, taking this photo of Taughannock Falls with a telescopic lens from the bridge downstream.

Walk the South Rim Trail to get a different view of Taughannock Falls.

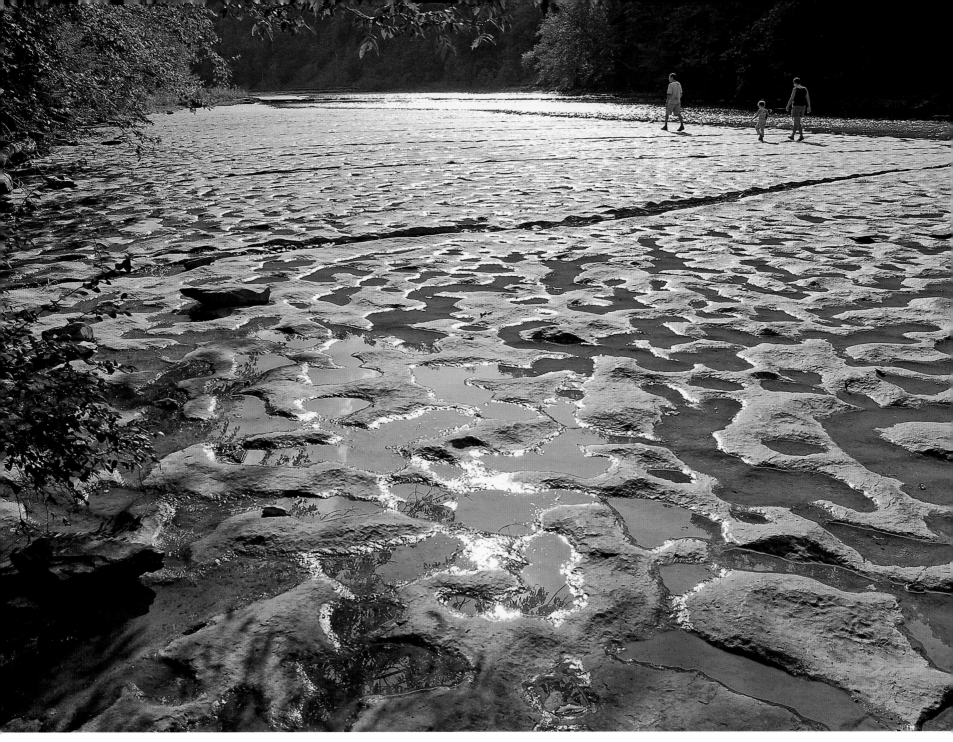

As water levels diminish in late summer, the sculptured design of Taughannock Gorge's weathered limestone floor is exposed. Farther up, the canyon walls rise 400 feet.

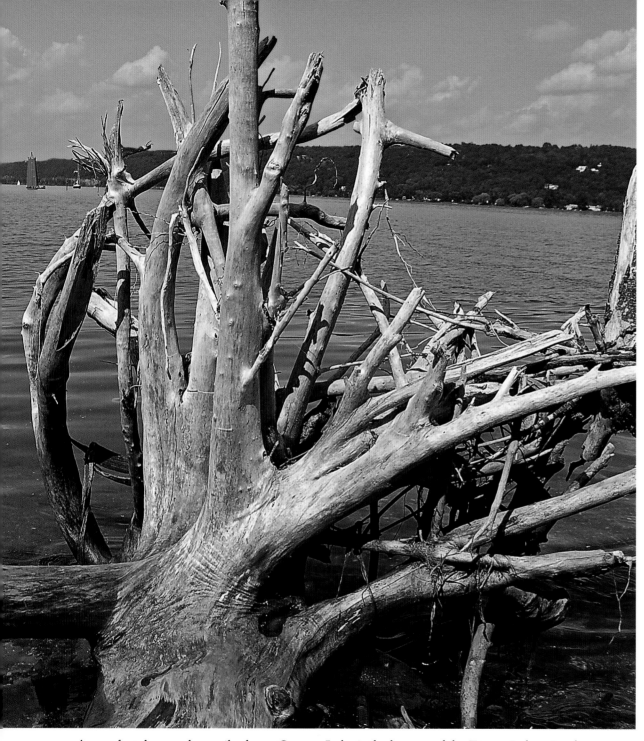

At 435 feet deep and 40 miles long, Cayuga Lake is the longest of the Finger Lakes. Its shores were home to the Cayuga people of the Iroquois Confederacy.

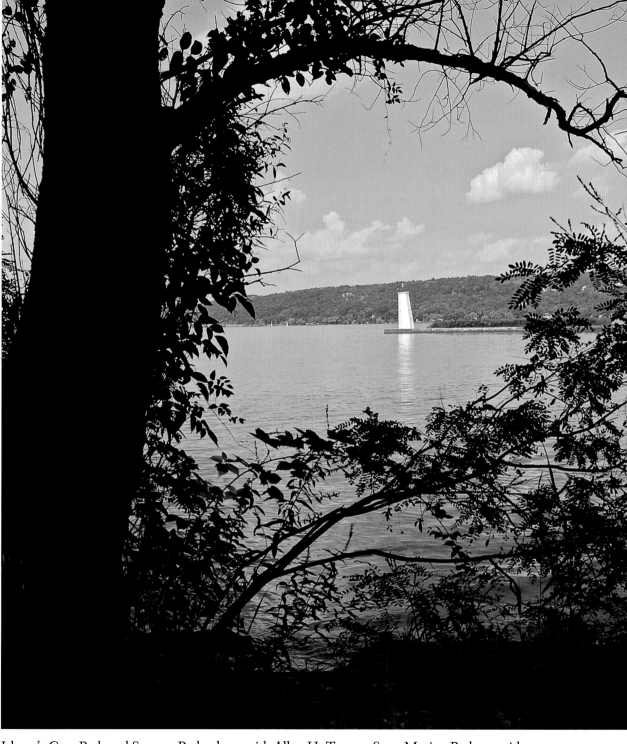

Ithaca's Cass Park and Stewart Park, along with Allan H. Treman State Marine Park, provide ample boating opportunities, as well as views of the Cayuga Inlet.

79

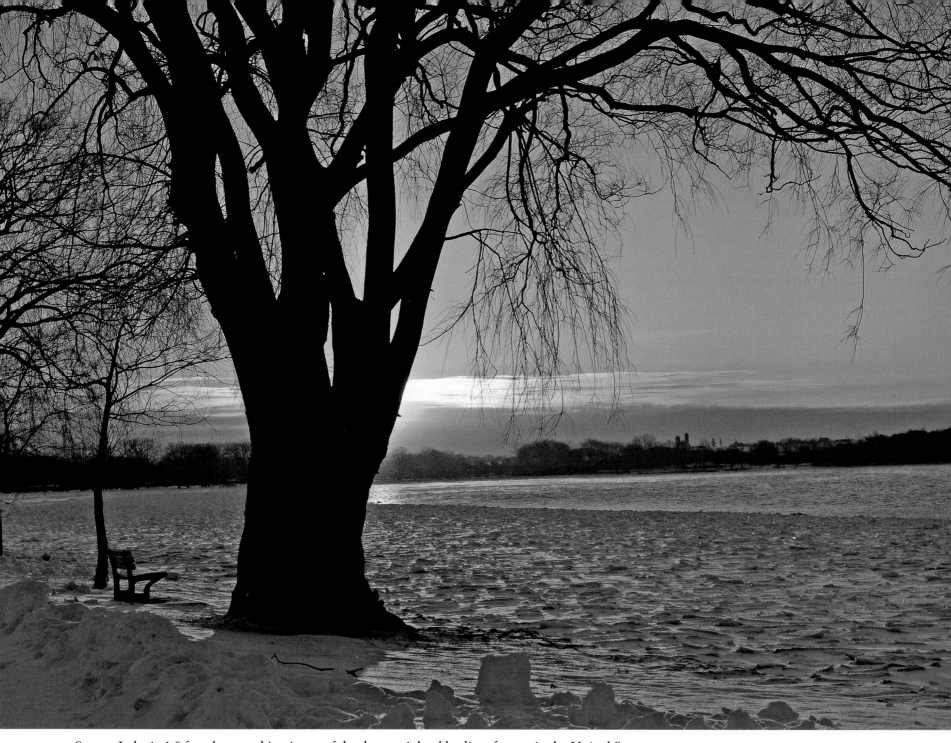

Seneca Lake is 618 feet deep, making it one of the deepest inland bodies of water in the United States.

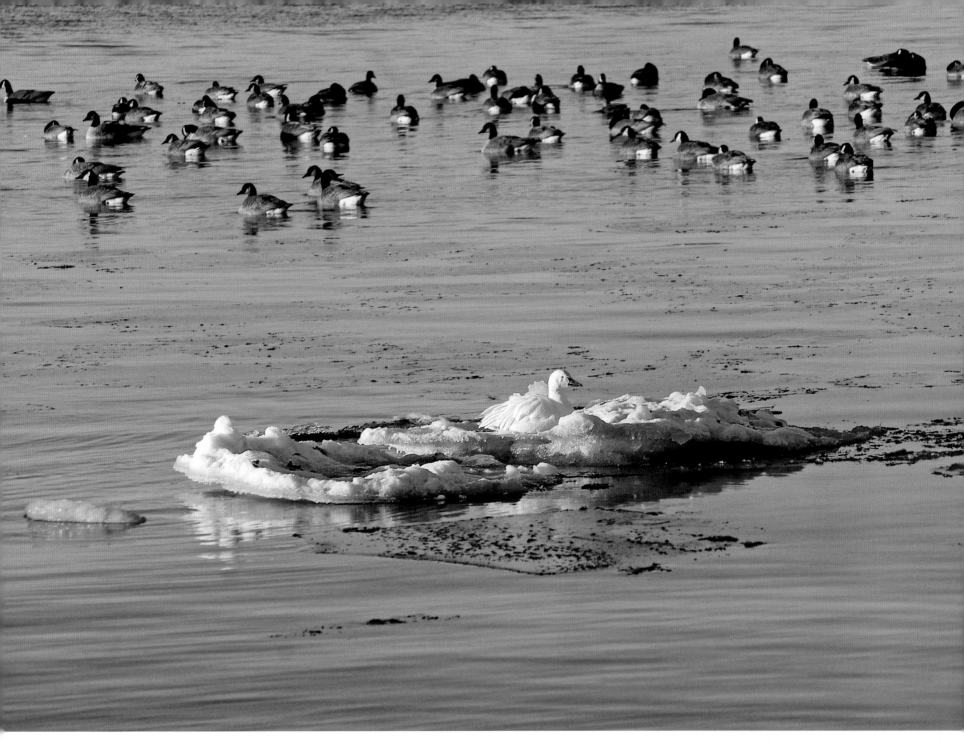

In mid-February, a small piece of drift ice on Seneca Lake makes a convenient resting spot.

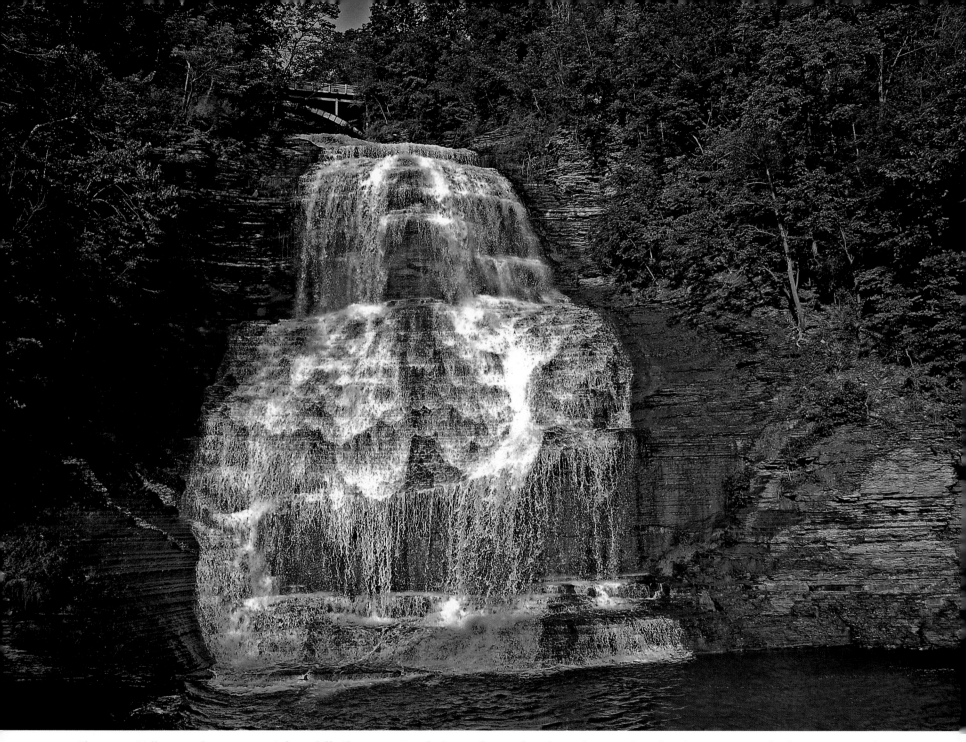

Shequaga Falls cascades over a 156-foot cliff. Shequaga Creek descends 400 feet through 1¼ miles of rocky canyon, with alternating rapids, falls, and pools.

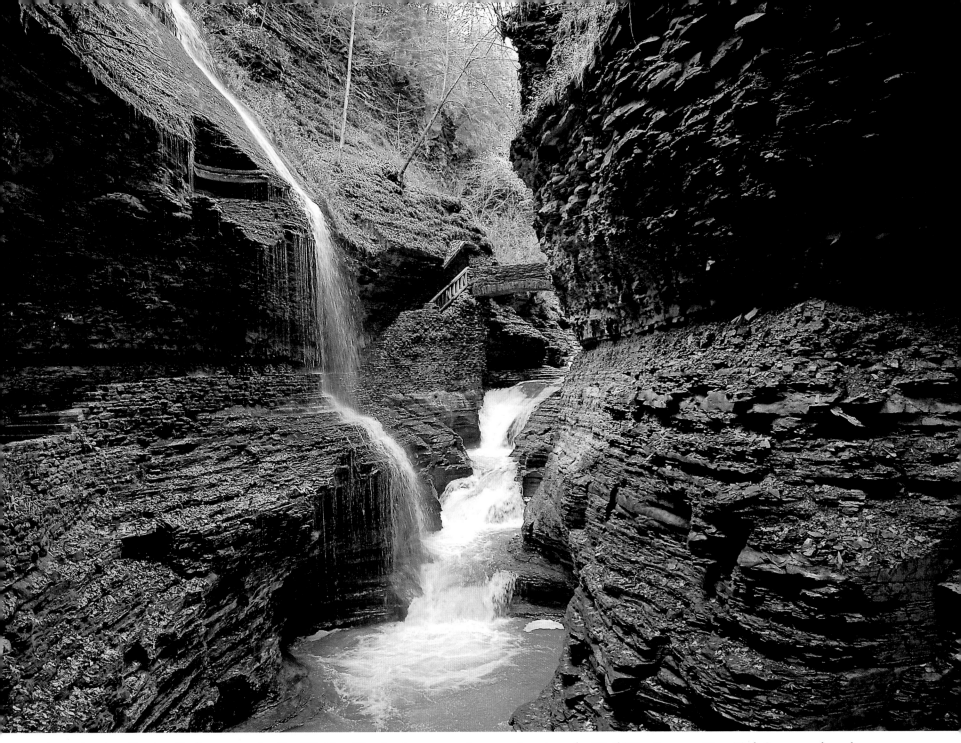

Once the site of hydraulically powered mills, Watkins Glen has been a tourist attraction since the Civil War. In 1903, New York State purchased 103 acres, preserving a part of what is now a 776-acre state park. This is Rainbow Falls.

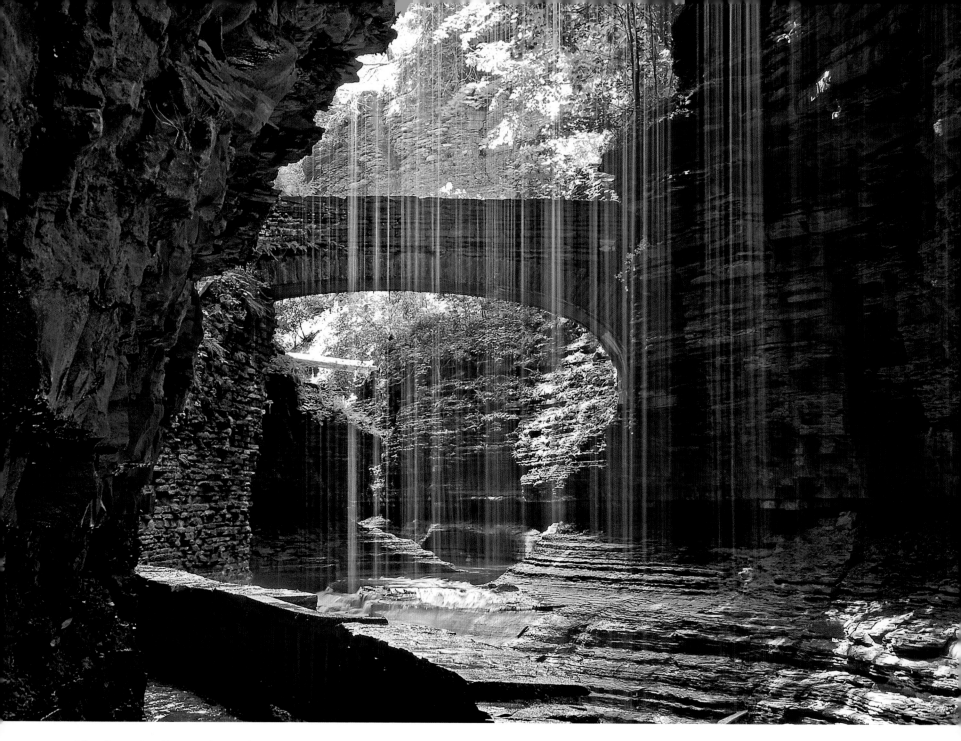

The Gorge Trail at Watkins Glen State Park is a mile and a half long and includes 800 steps. Walk underneath Rainbow Falls to cool off in the summer heat.

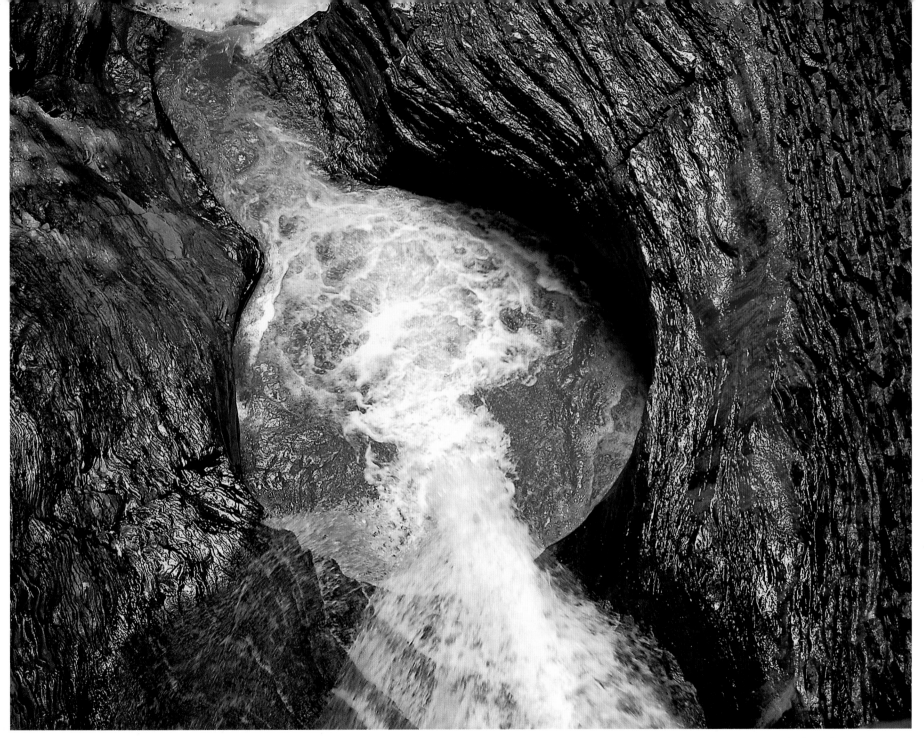

The forces of nature are constantly at work reshaping the glen. Rapidly swirling water has carved a perfect pothole in the rocks just below the park's Cavern Cascade.

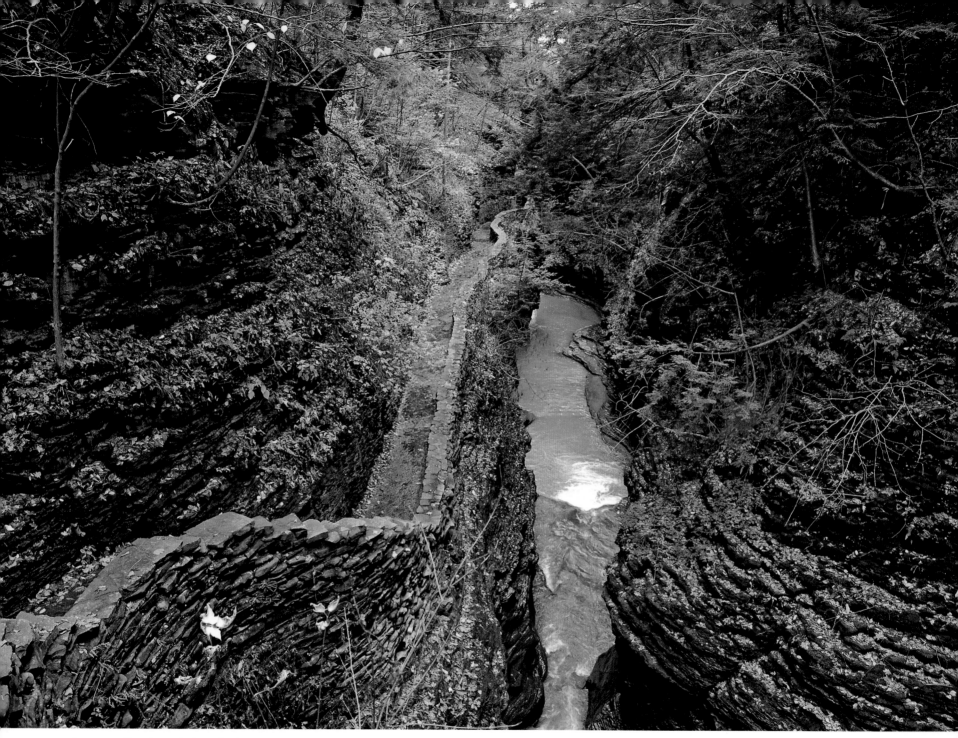

In 1935, flooding did such damage to the park's concrete and iron walkways that the Civilian Conservation Corps (CCC) and the Works Progress Administration (WPA) replaced them with the natural-looking fieldstone masonry we see today.

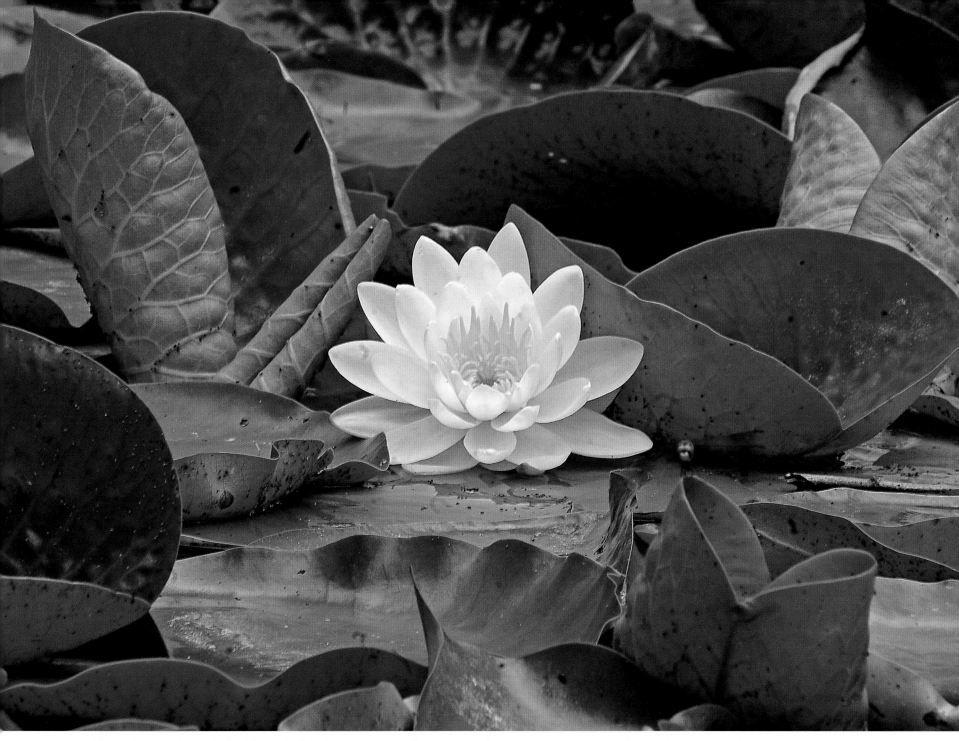

A water lily pushes up through the lily pads that dominate a small pond near the south entrance of Watkins Glen State Park.

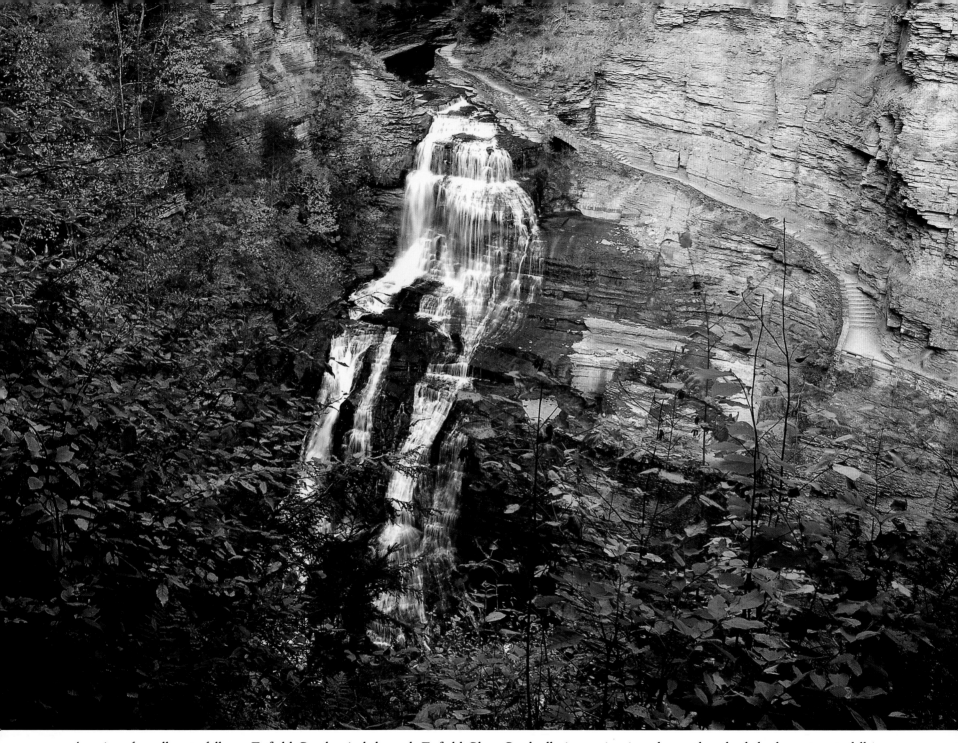

A series of small waterfalls on Enfield Creek wind through Enfield Glen. Gradually increasing in volume, they feed the largest waterfall in Robert H. Treman State Park, the 115-foot-high Lucifer Falls, here viewed from the Rim Trail.

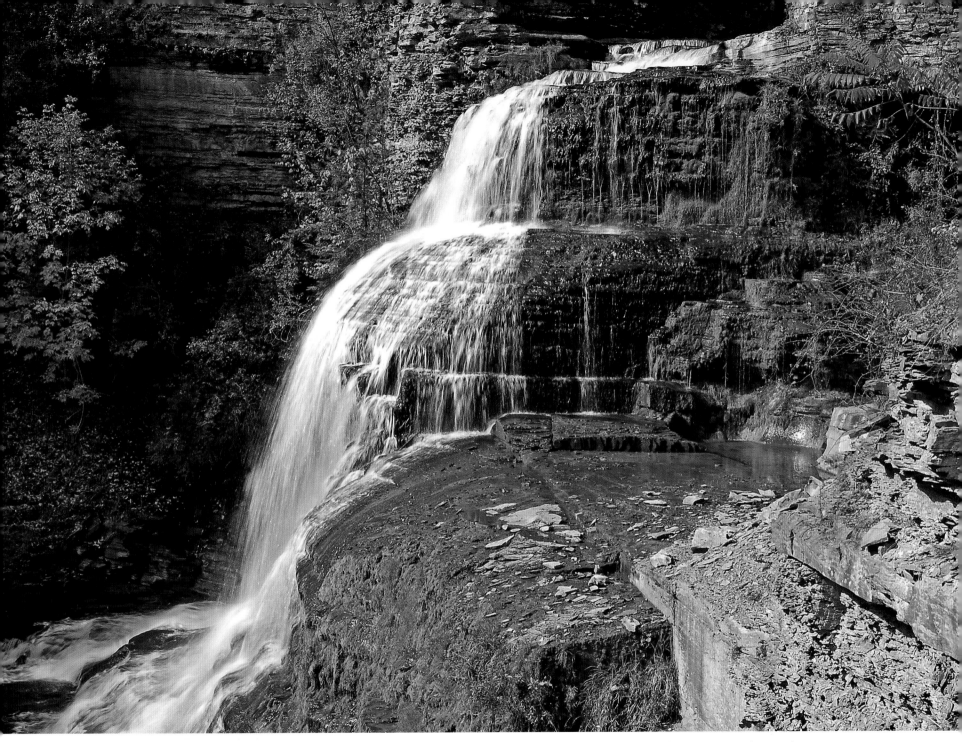

The Gorge Trail at Robert H. Treman State Park after a heavy rain. One less-traveled hike connects the north entrance to the south entrance, passing more than ten additional waterfalls.

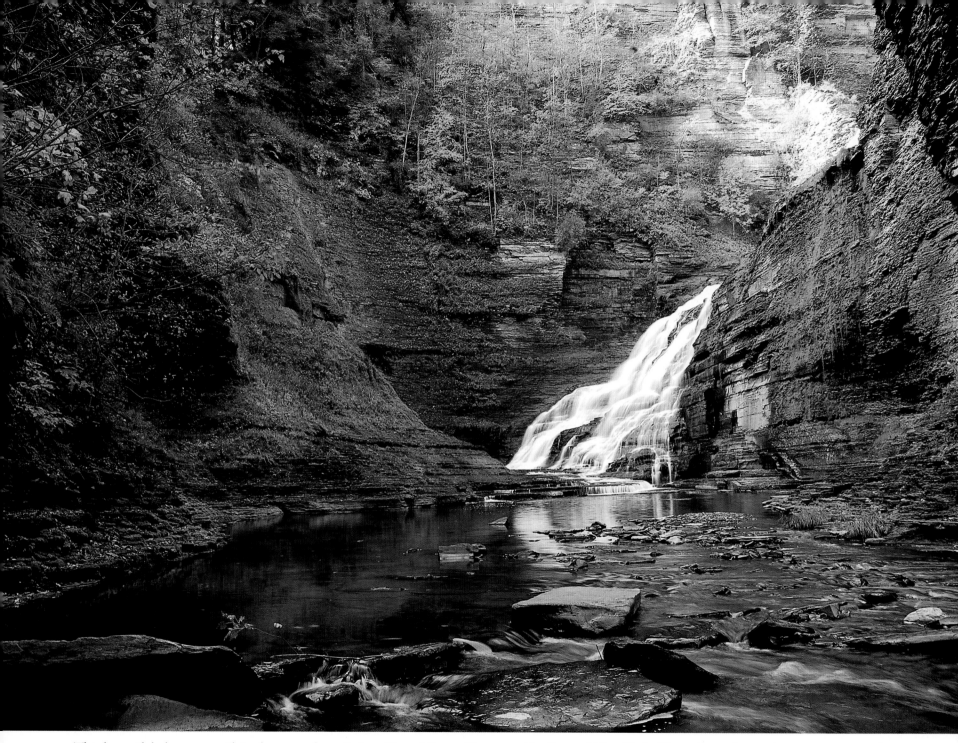

This beautiful glen was a gift in the 1920s from Robert H. and Laura Treman to the State of New York. The state park now has 1,000 acres and four hiking trails—three that run the length of the park.

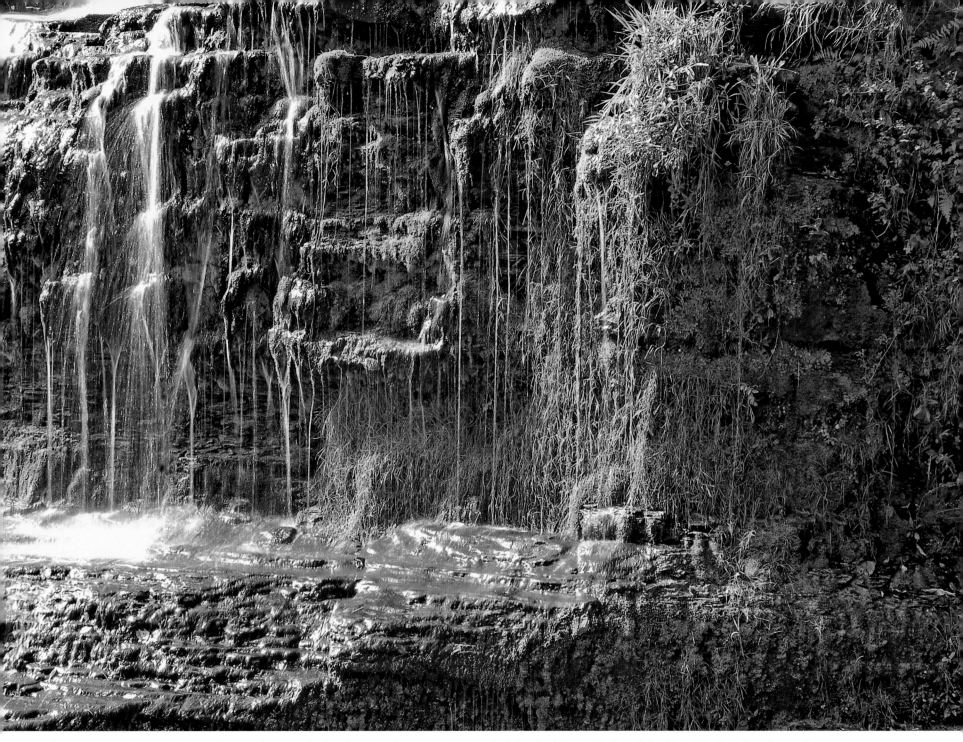

The Finger Lakes Trail skirts the southern end of Robert H. Treman State Park. The Red Pine Trail and the Rim Trail make a loop above the glen, while the Gorge Trail allows for more close-up views.

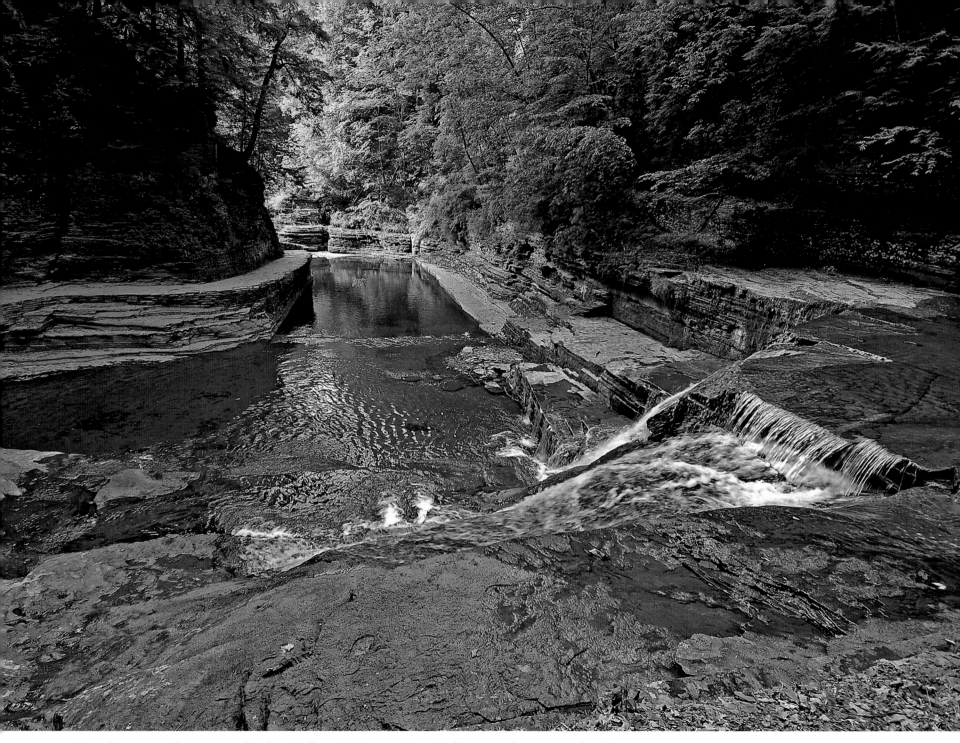

In early summer, lower water levels at Robert H. Treman State Park expose algae-covered rocks.

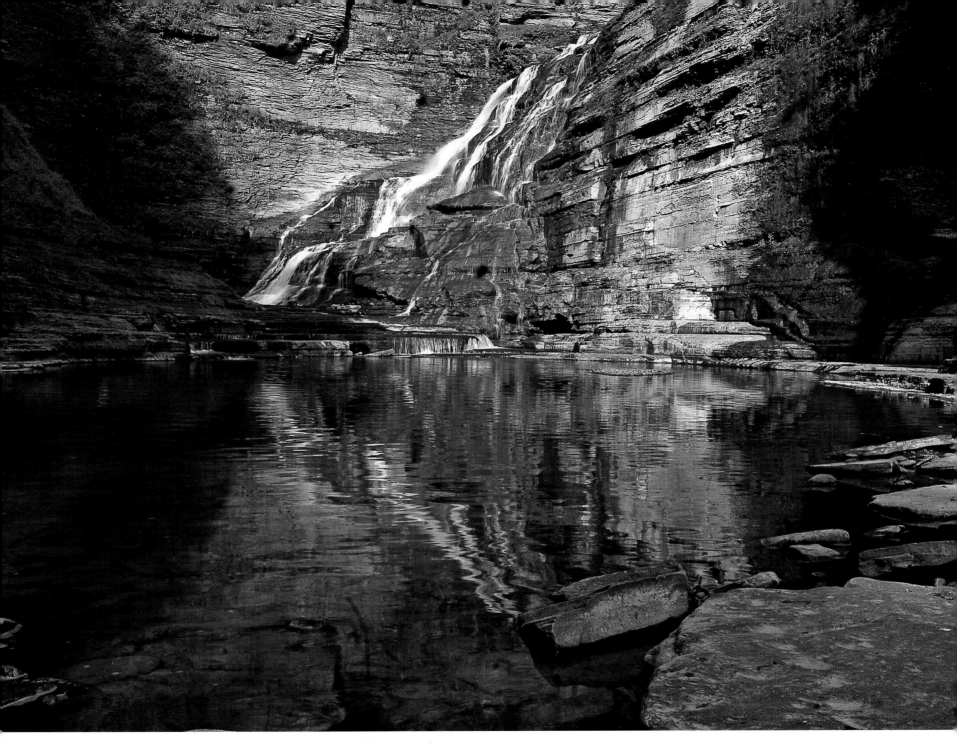

The base of Lucifer Falls in Robert H. Treman State Park during early summer.

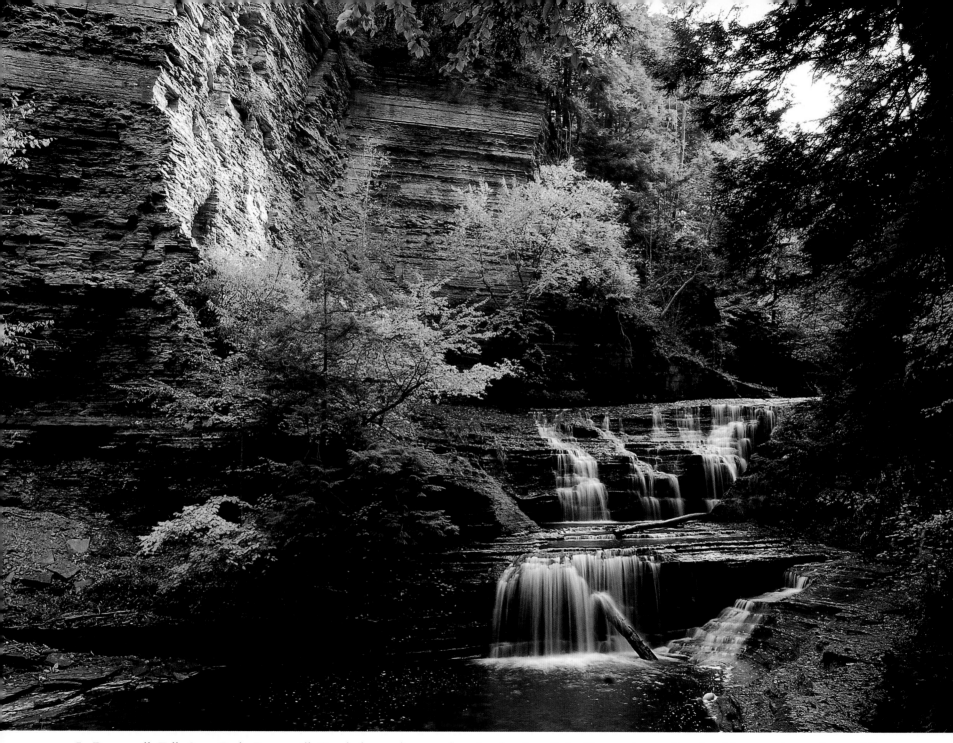

In Buttermilk Falls State Park, Buttermilk Creek descends more than 600 feet from Lake Treman in a series of rapids, cascades, and waterfalls that eventually empty into Cayuga Lake.

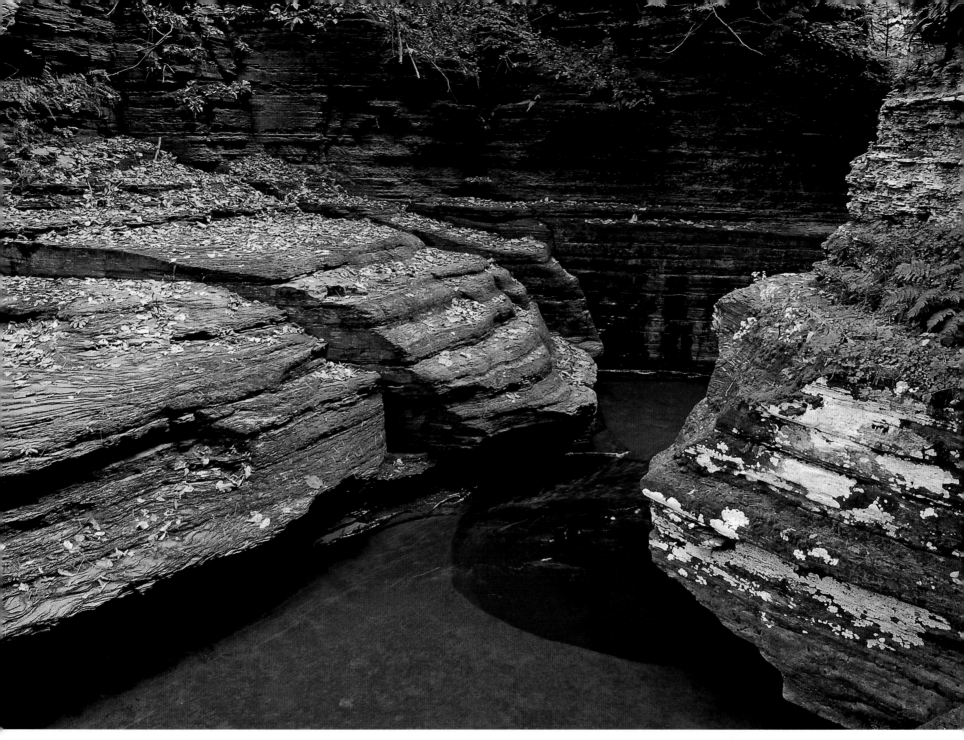

Potholes and plunge pools are numerous in Buttermilk Falls State Park. These circular pools can be deceptively deep, some more than 6 feet.

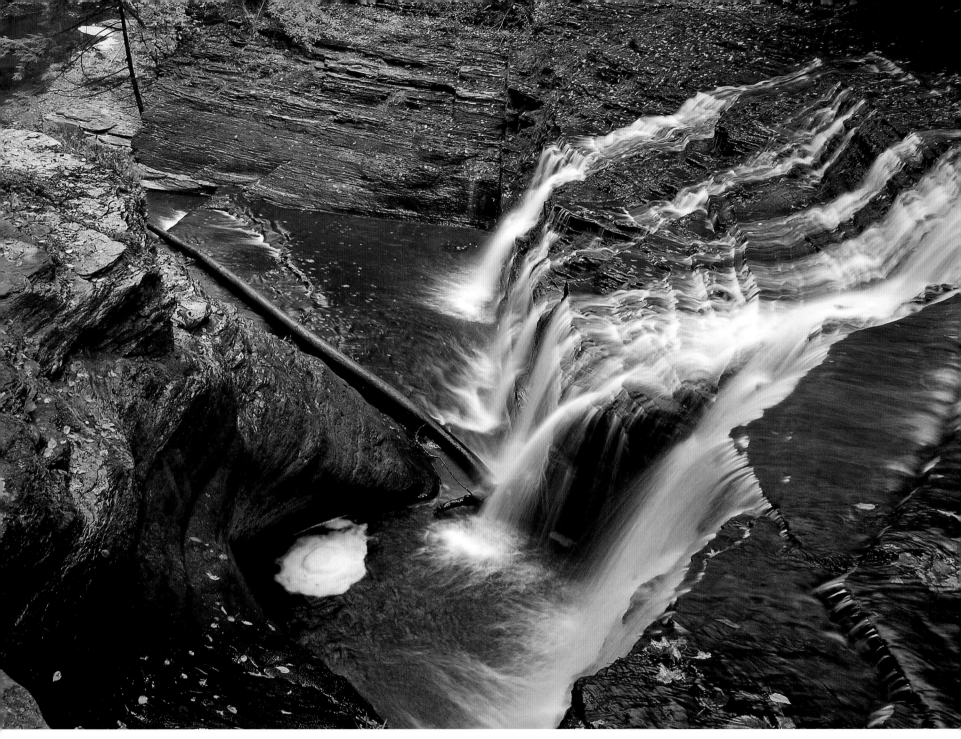

Near the upper entrance of Buttermilk Falls State Park, the creek winds through sculptured rock and tumbles over many beautiful 10-foot waterfalls.

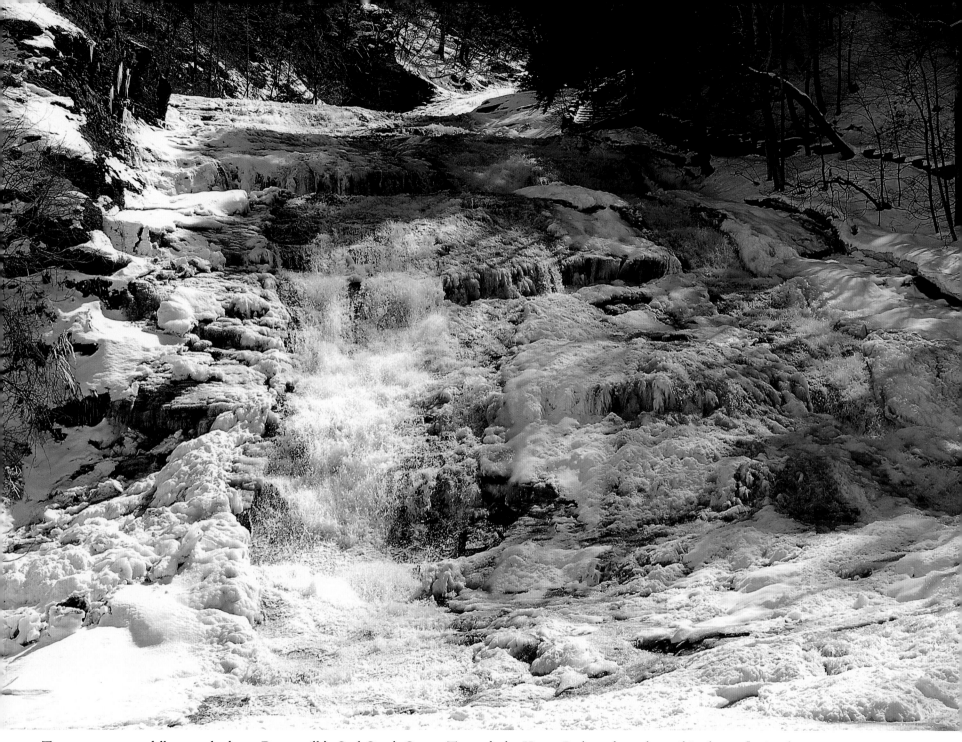

Ten separate waterfalls cascade down Buttermilk's Owl Creek Gorge. To reach the Upper Park—where the trail is almost flat in places—you can either climb hundreds of steep steps, or drive to the upper entrance.

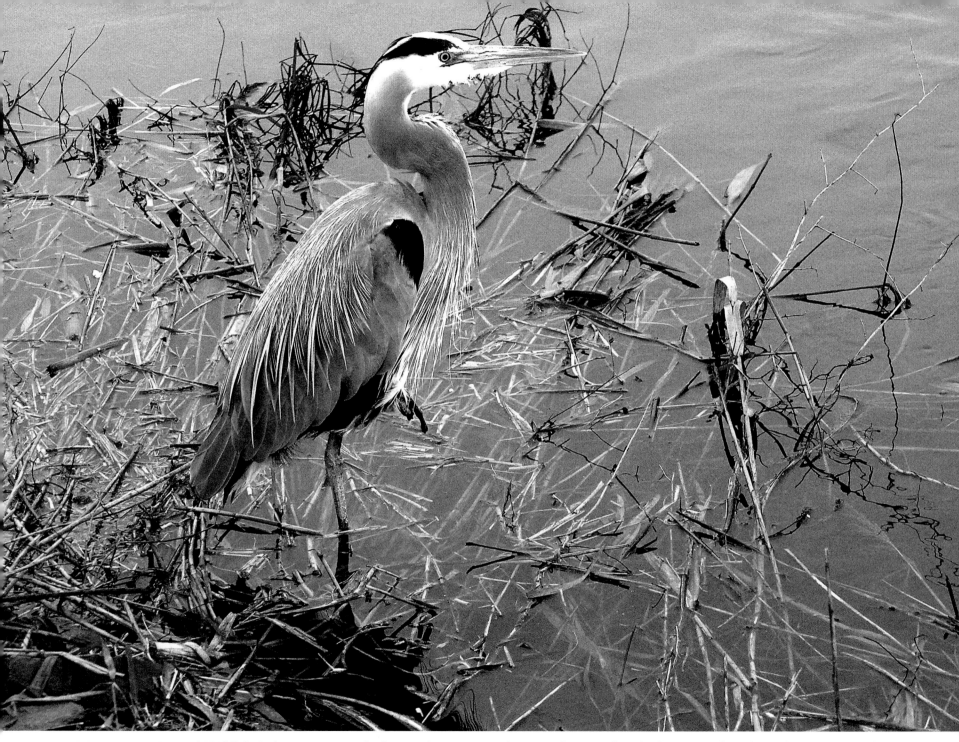

Montezuma National Wildlife Refuge is a major feeding and resting area for more than two hundred species of native and migratory birds, amphibians, reptiles, and mammals. An estimated one million birds visit Montezuma each year.

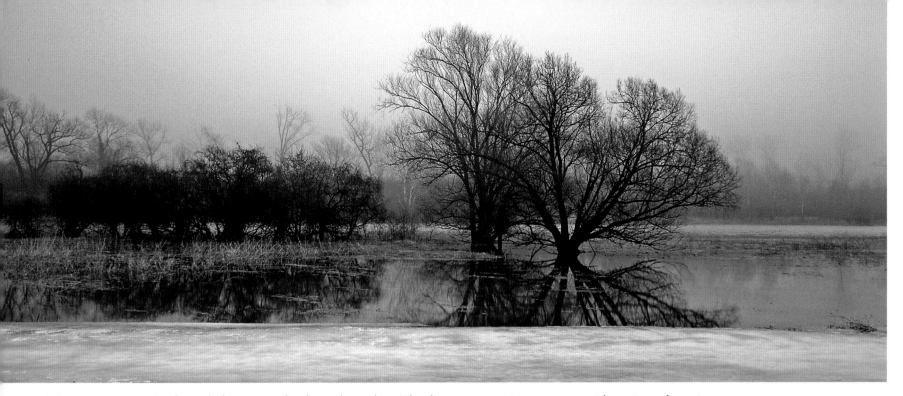

Montezuma is a mix of wooded areas, wetlands, and marshes. The diverse vegetation attracts a wide variety of species.

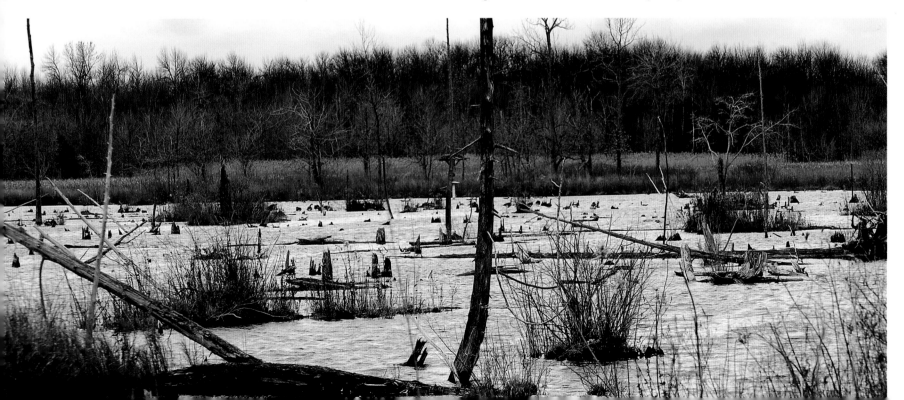

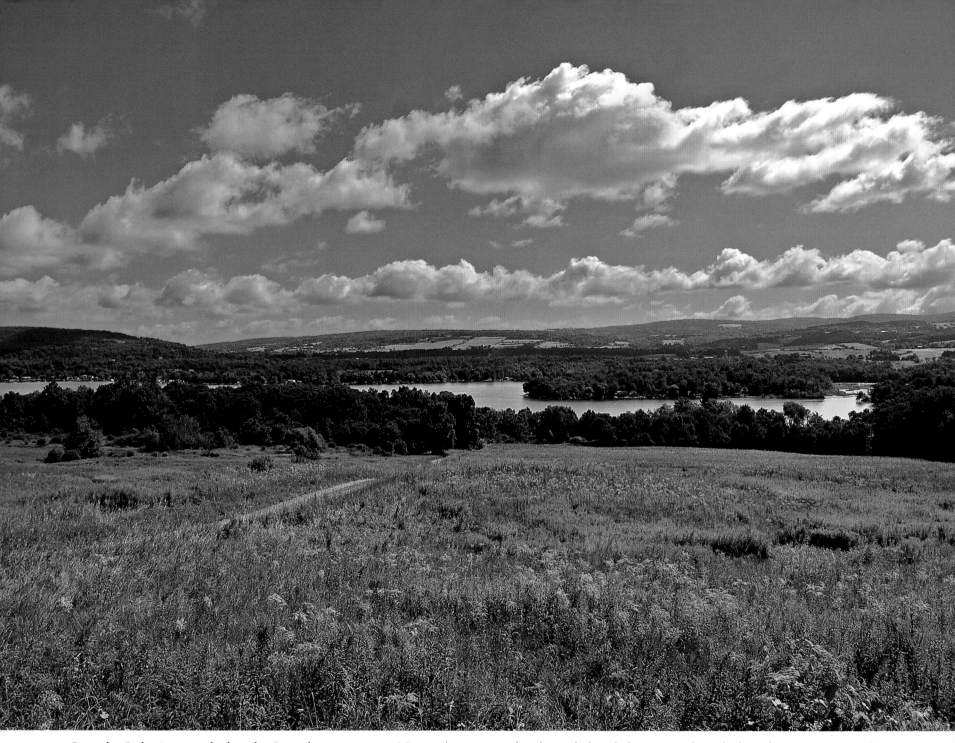

Lamoka Lake is named after the Lamoka, an ancient Native American tribe that inhabited this region long before the Seneca arrived.

"Lamoka" means "mud lake."

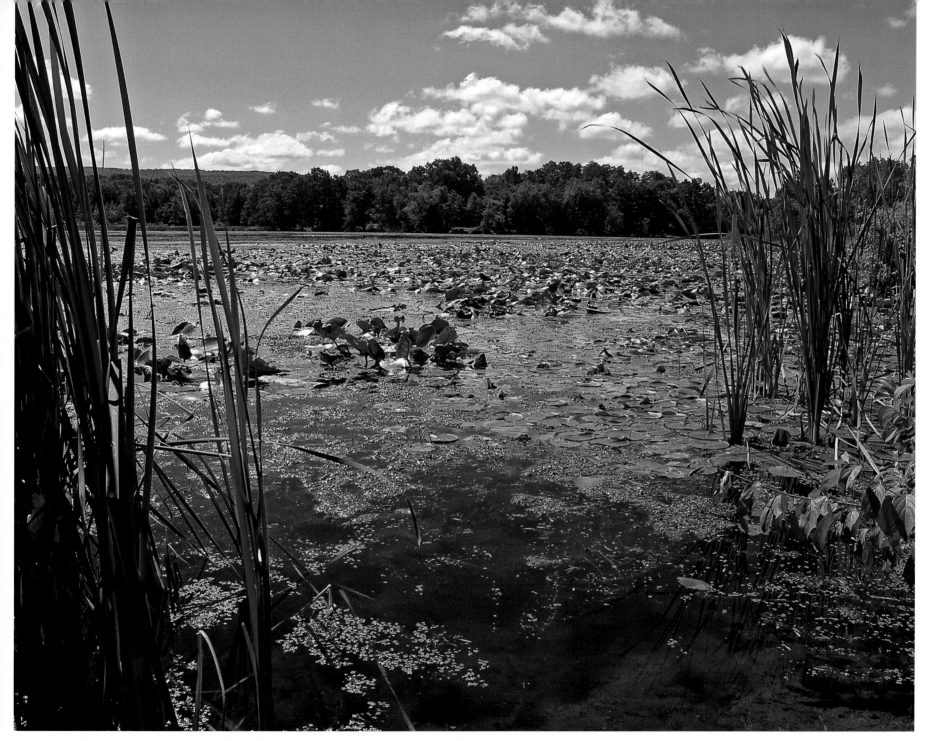

Near the town of Bradford, Mill Pond is connected to the southwest end of Lamoka Lake by Mud Creek. These weed beds provide habitat for large- and smallmouth bass as well as yellow perch.

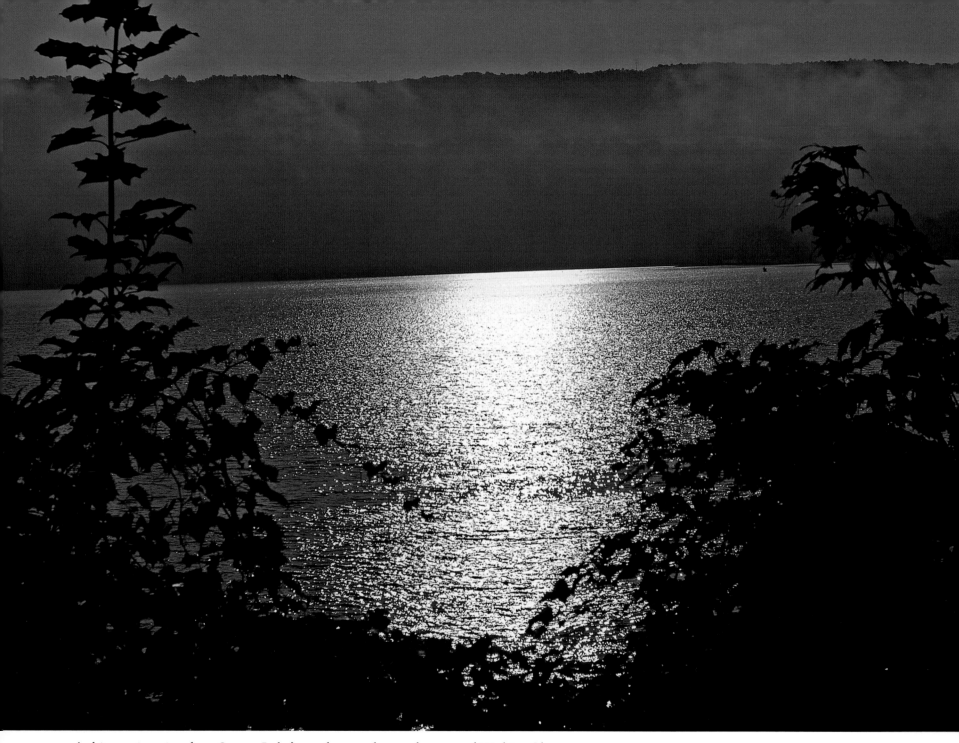

A shimmering view from Seneca Lake's southern end, near the town of Watkins Glen.

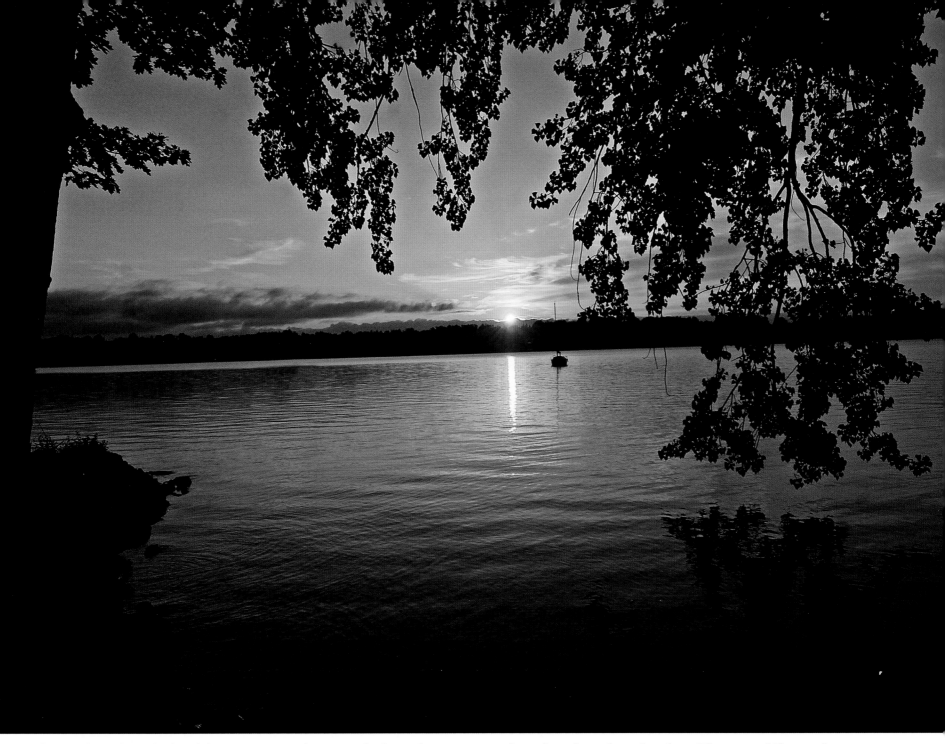

Skaneateles Lake is the fourth largest Finger Lake at 16 miles long, three-quarters-of-a-mile wide, and 300 feet deep. The town of Skaneateles is at the north end of the lake.

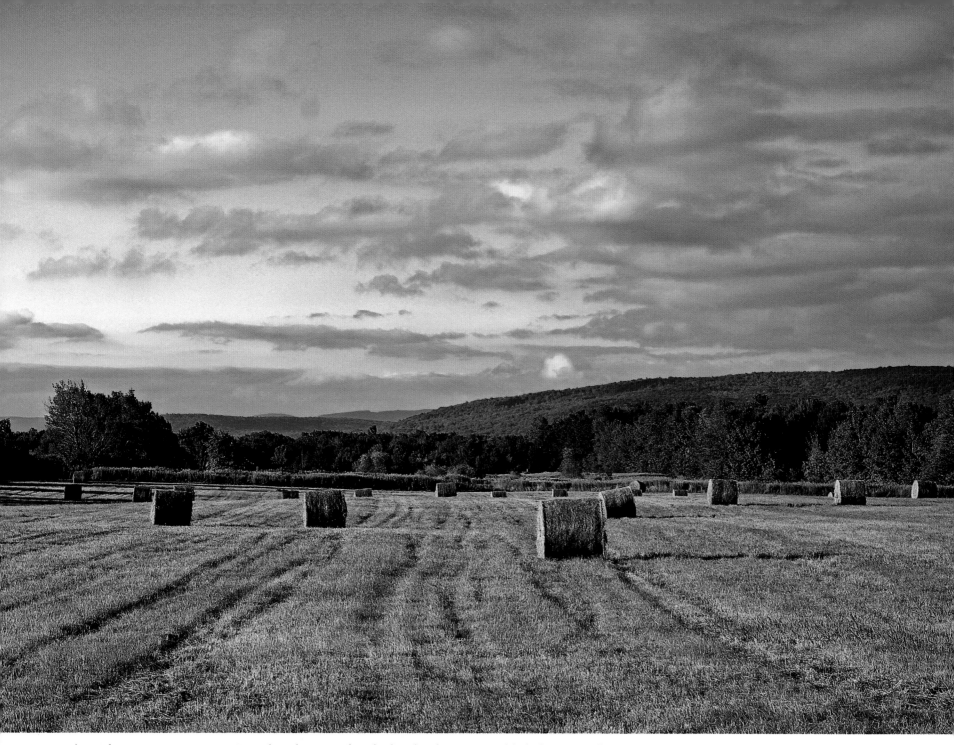

An early morning vista, near Prattsburgh, soon after the hay has been cut and baled. Some roll it, some put it in square bales, some just stack it in large piles, and some encase it in plastic.

Owasco Lake, photographed during a very humid and warm sunrise. These views are from Route 38 and from Emerson Park pier. Although I have photographed many sunrises, I have never seen the sun this red so high in the sky. The lake's name is the Iroquoian word for "the crossing."

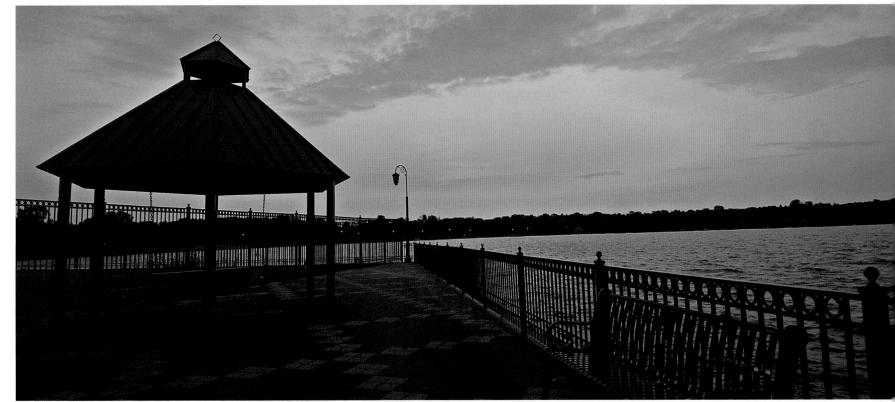

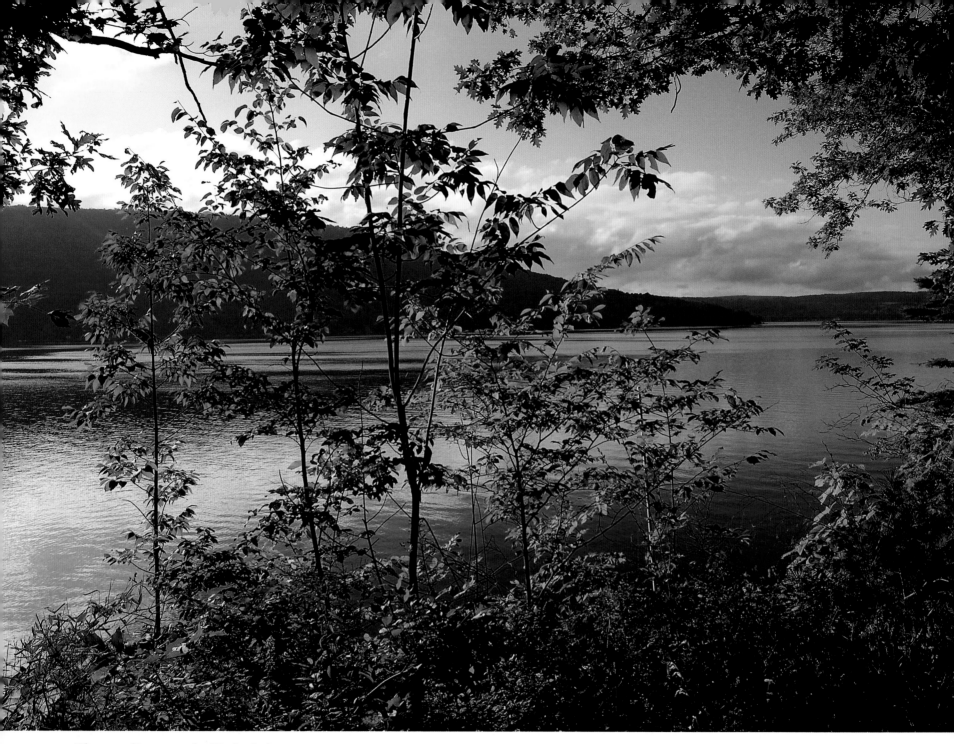

The sun glistens on the Keuka Lake waters.

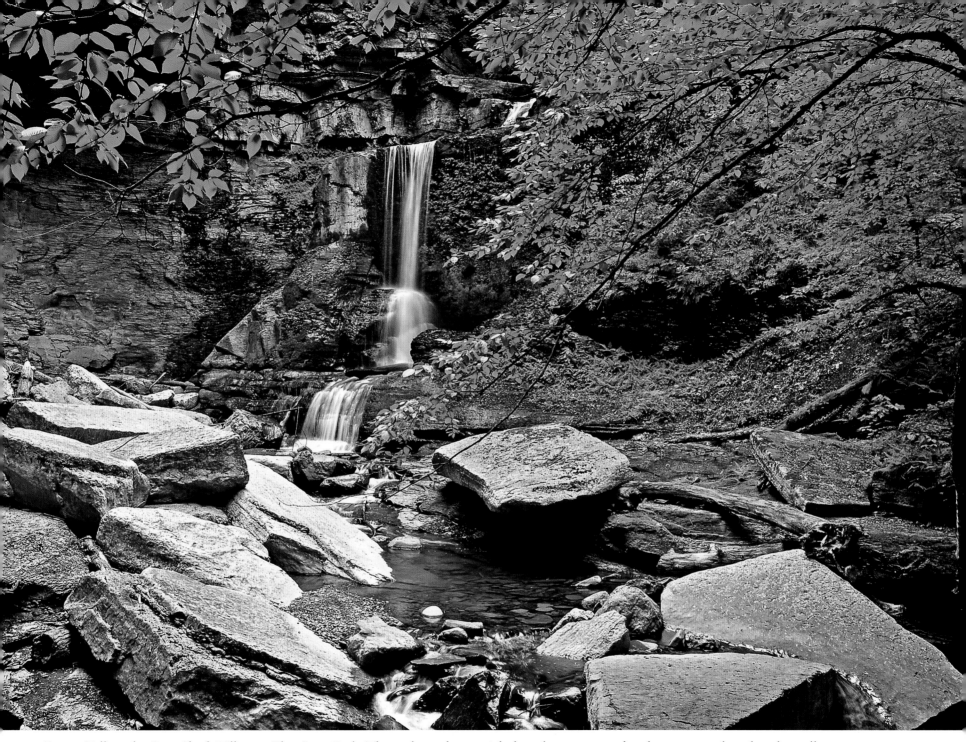

Lower Falls at the Cow Shed, Fillmore Glen State Park. The rock overhang might have kept cows cool on hot summer days, but the walk to get there would have been difficult. The park was named for the thirteenth U.S. president, Millard Fillmore.

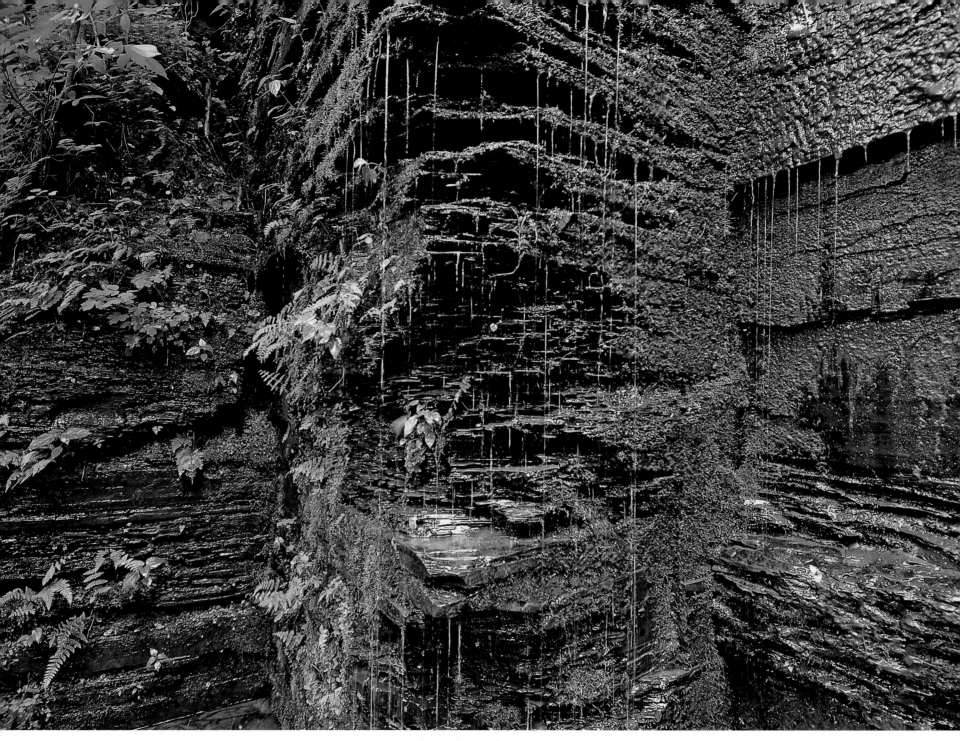

The main Gorge Trail at Fillmore Glen State Park wanders through lush forest with water dripping intermittently from the cliffs high above.
Visitors may also hike along the park's North and South Rim trails.

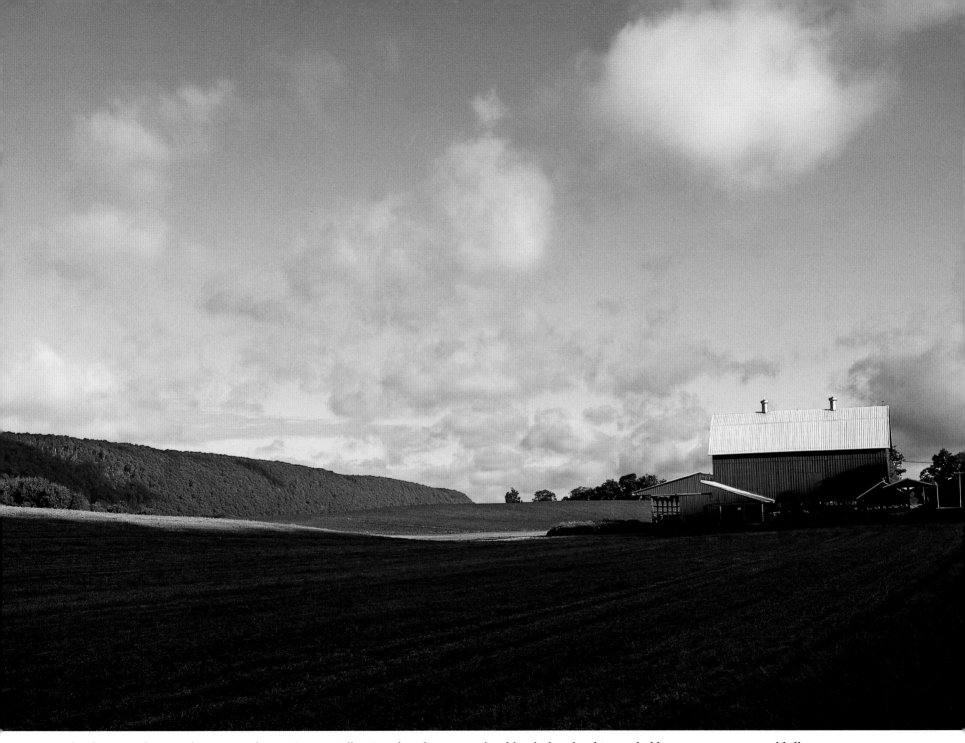

On the drive north toward Otisco Lake on Otisco Valley Road, mile upon mile of fertile farmland is nestled between tree-covered hills.

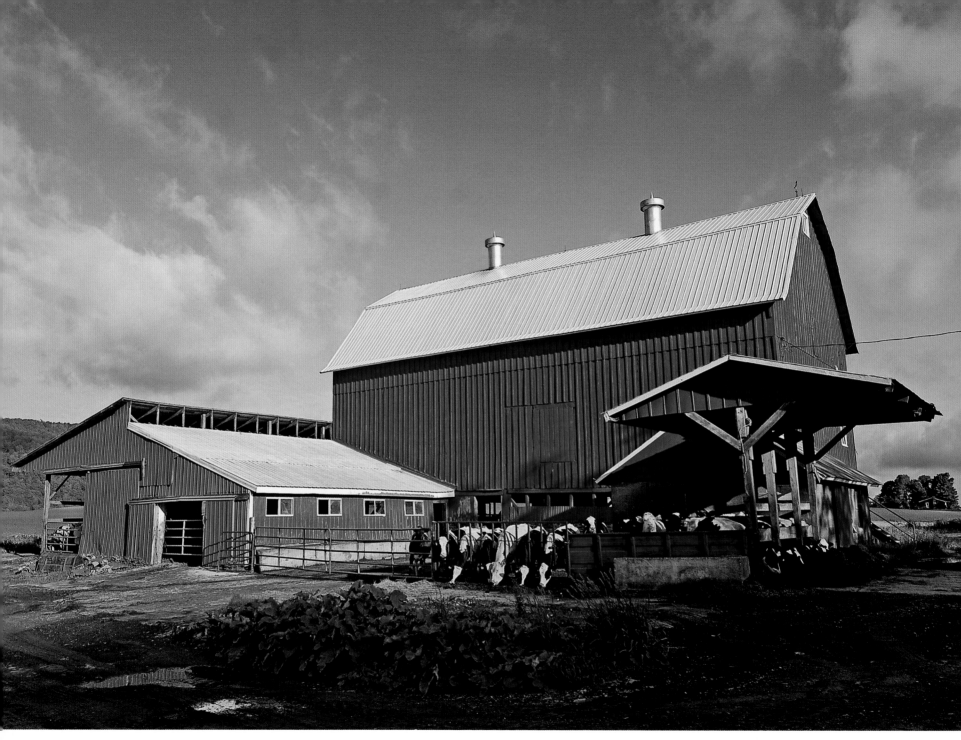

Holstein cows enjoy their early morning feeding.

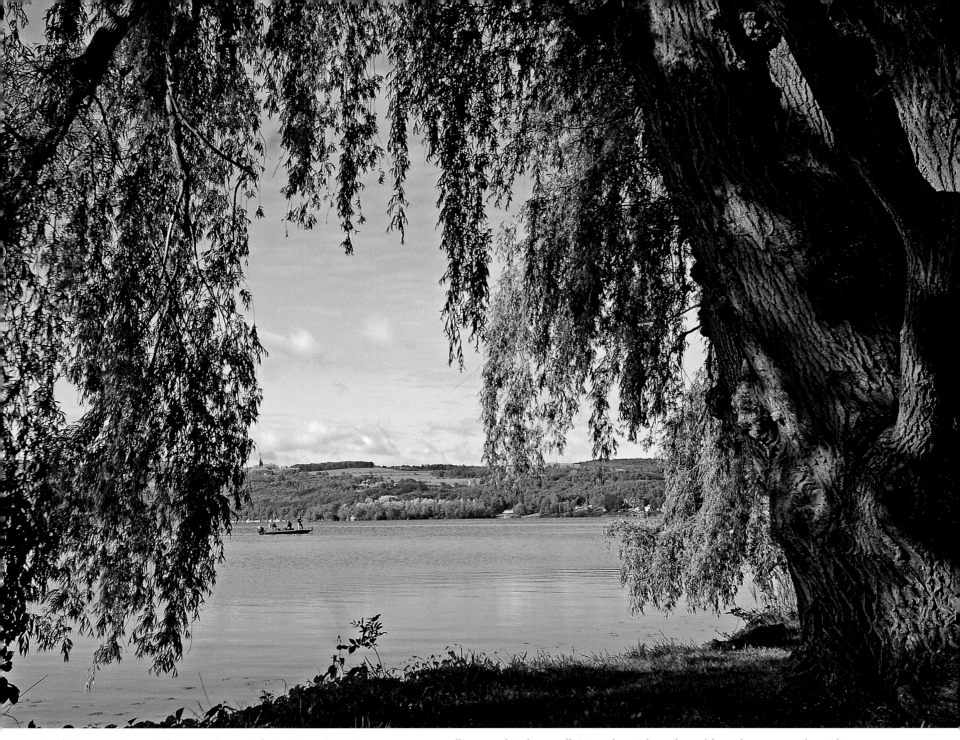

Fishing on Otisco Lake near dawn. The Native American name means "waters dried away." Six miles in length and less than one mile wide, Otisco Lake is the third shortest of the Finger Lakes.

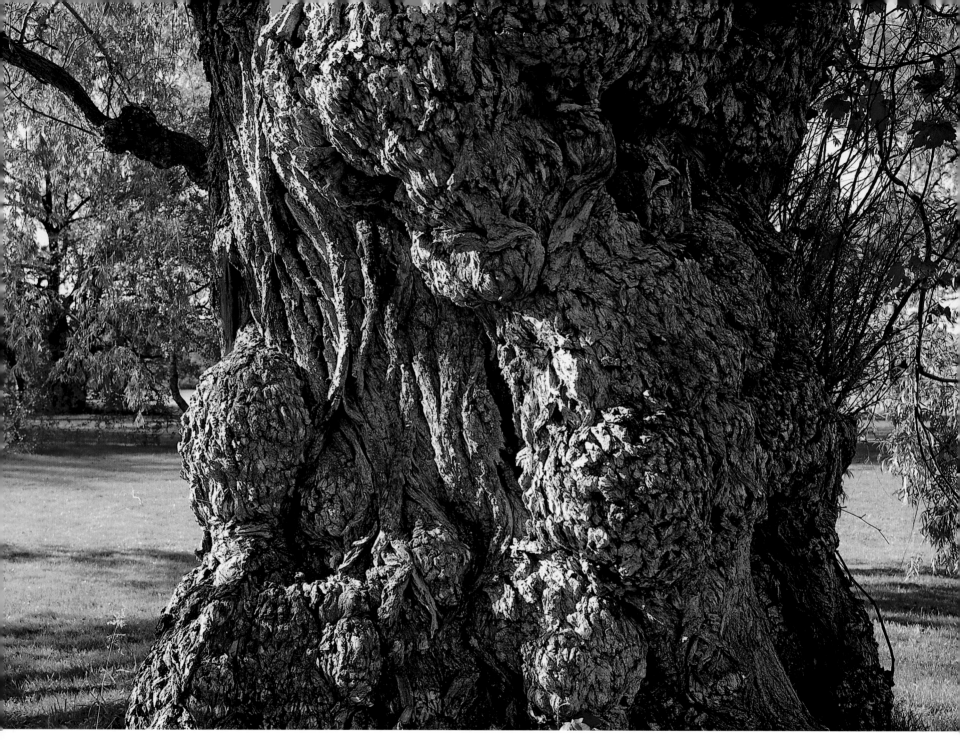

Otisco Lake Park is dominated by huge willow trees with gnarled trunks more than 4 feet wide.

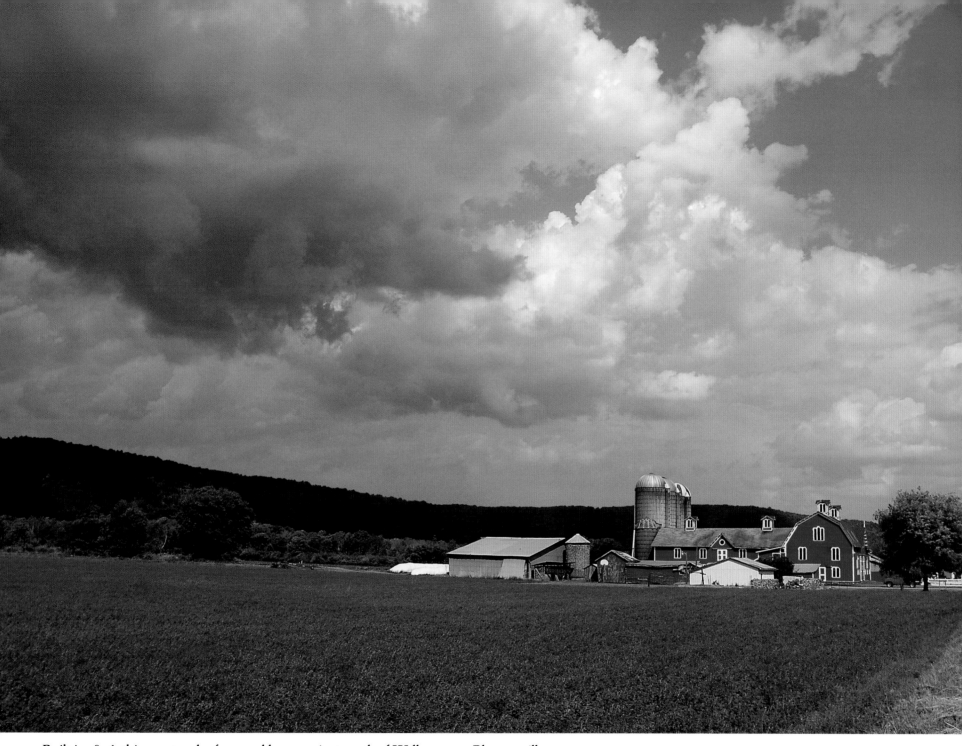

Built in 1876, this spectacular farm and barn are just south of Wallace, near Bloomerville.

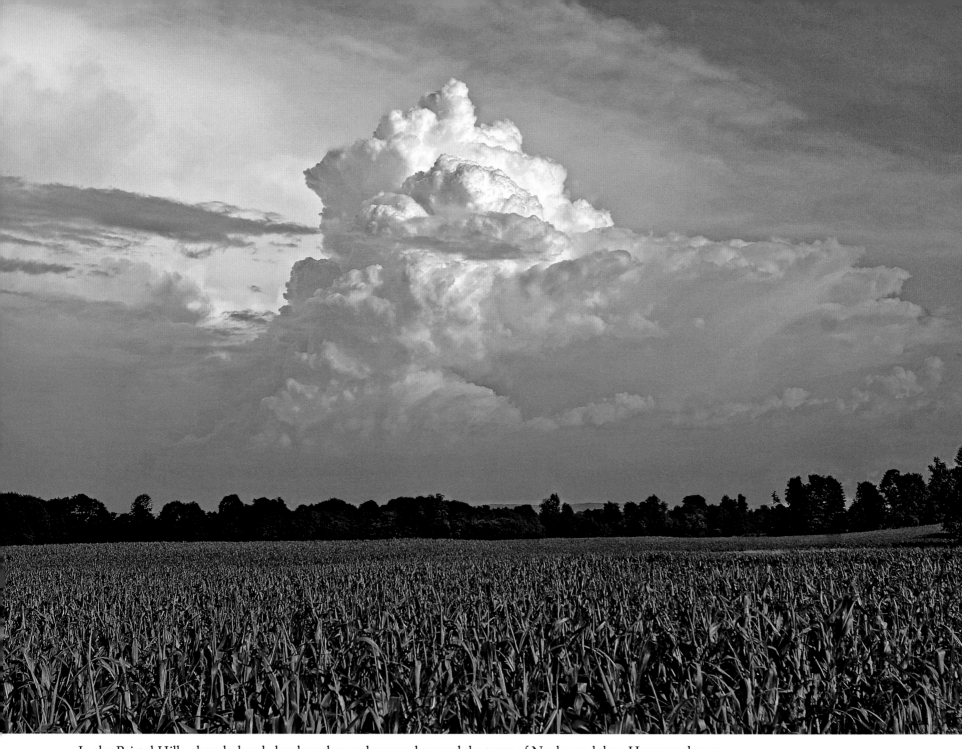

In the Bristol Hills, thunderhead clouds gather and proceed toward the town of Naples and then Hammondsport.

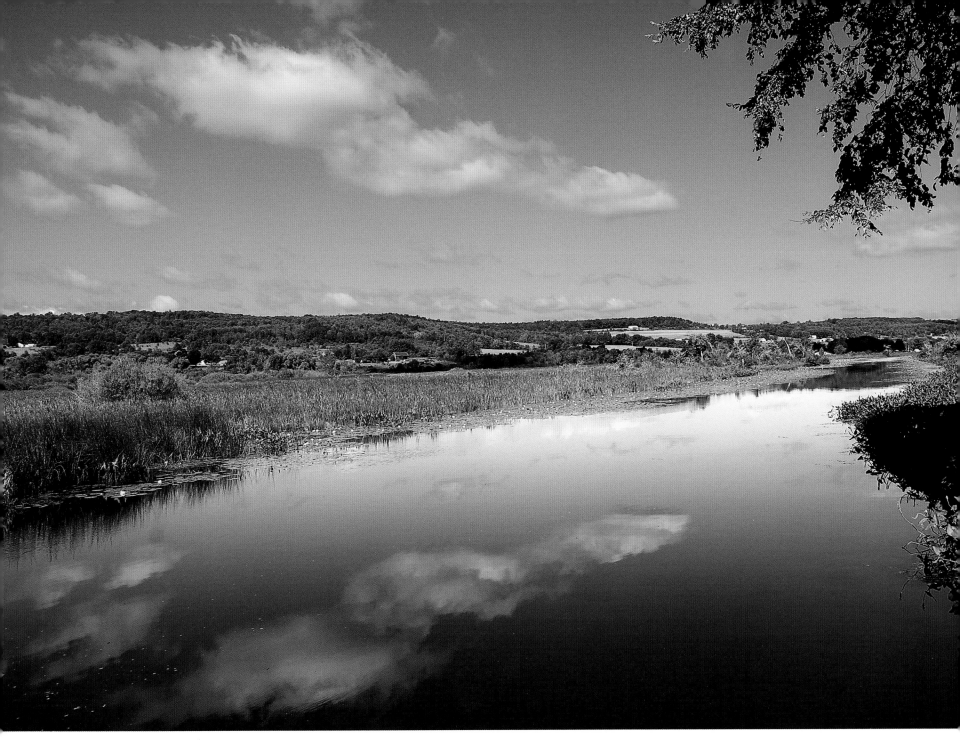

This shallow channel connects Lamoka and Waneta lakes, which supply water to the hydroelectric dam on Keuka Lake.

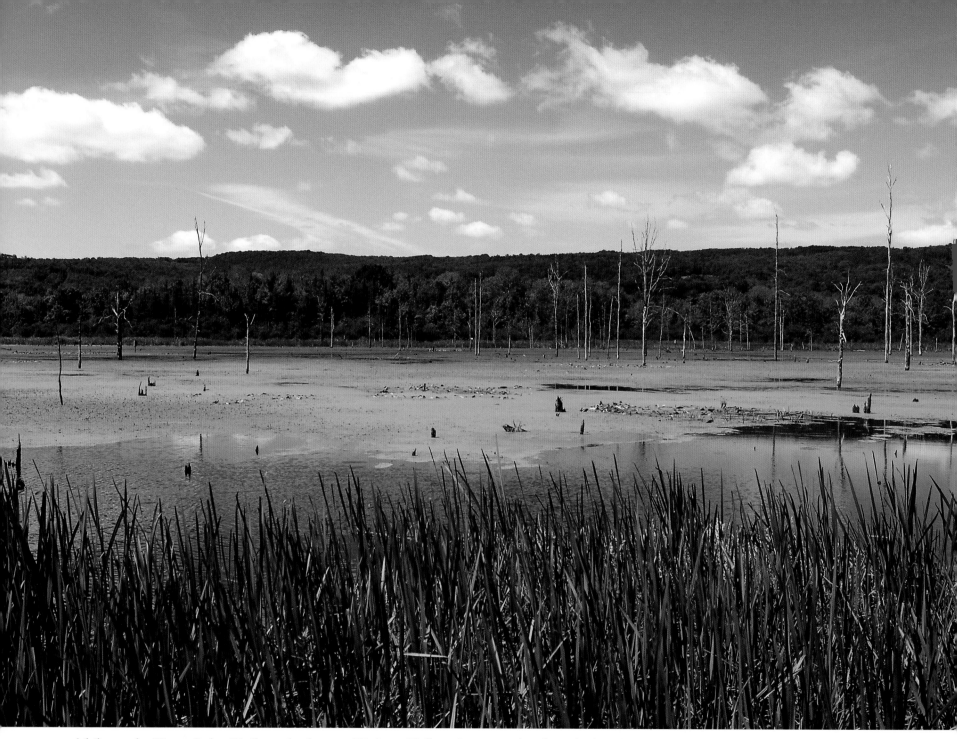

A hike on the Finger Lakes Trail may lead you to Birdseye Hollow County Park, where the boardwalk and observation deck are a favorite among fishermen and birdwatchers alike. A short, but soggy, herd path leads to views of the pond.

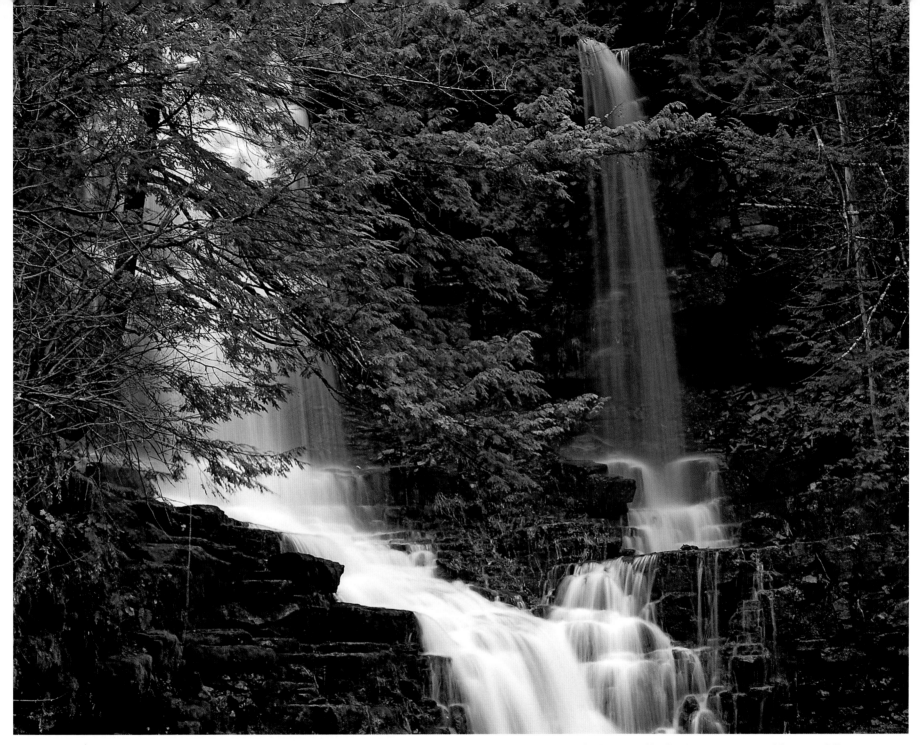

The Chittenango Creek cascades over jutting rock ledges on both the main waterfall and another slightly smaller but just as memorable waterfall in Chittenango Falls State Park.

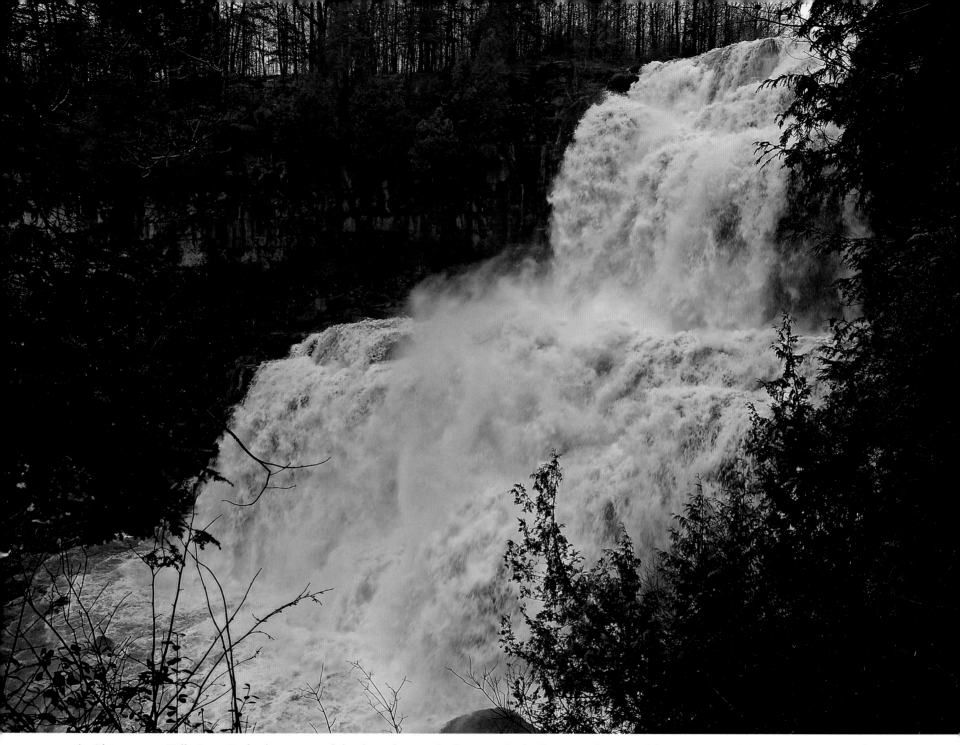

At Chittenango Falls State Park, the main path leads to this overlook area, which allows a side view of the main waterfall. Additional trail hikes are possible above the falls.

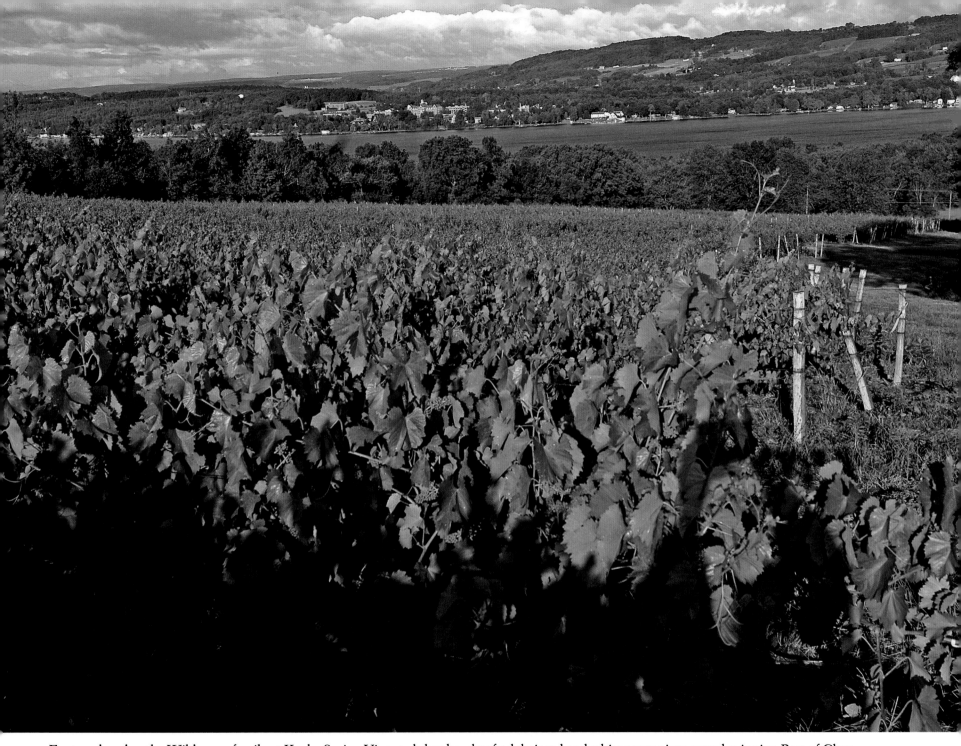

For two decades, the Wiltberger family at Keuka Spring Vineyards has handcrafted their red and white grapes into award-winning Best of Class wines. Their hillside tasting room adjacent to the vineyard allows for panoramic views of Keuka Lake.

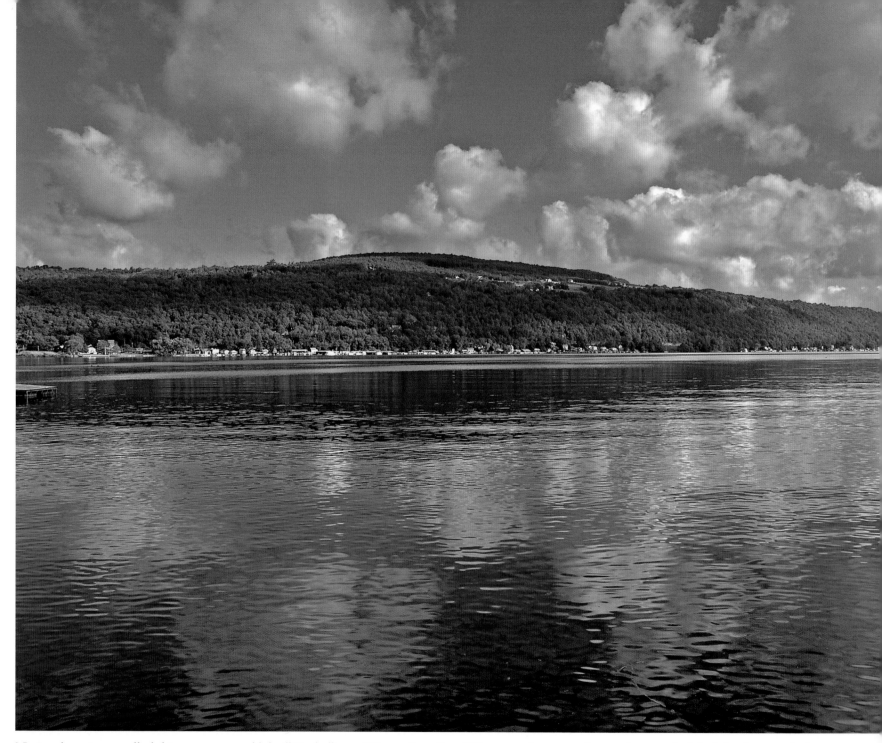

Native Americans called this two-pronged lake "Keuka"—or "Canoe Landing." Hammondsport, at the southern end of the lake, boasts ideal conditions for grape growing. By the 1880s the area was dotted with vineyards and wineries.

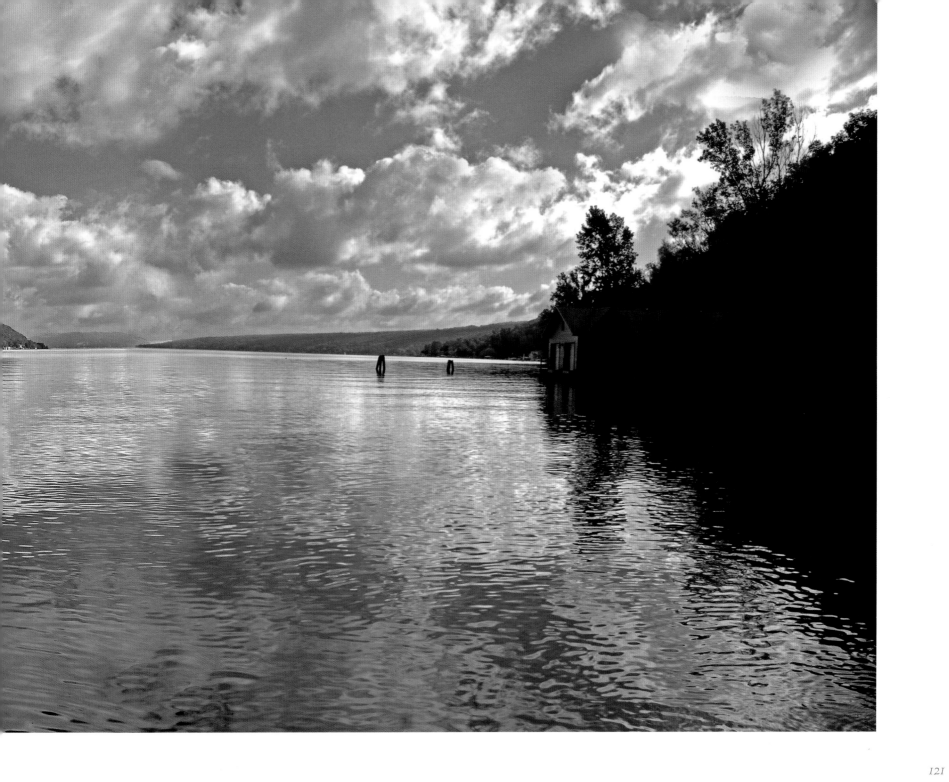

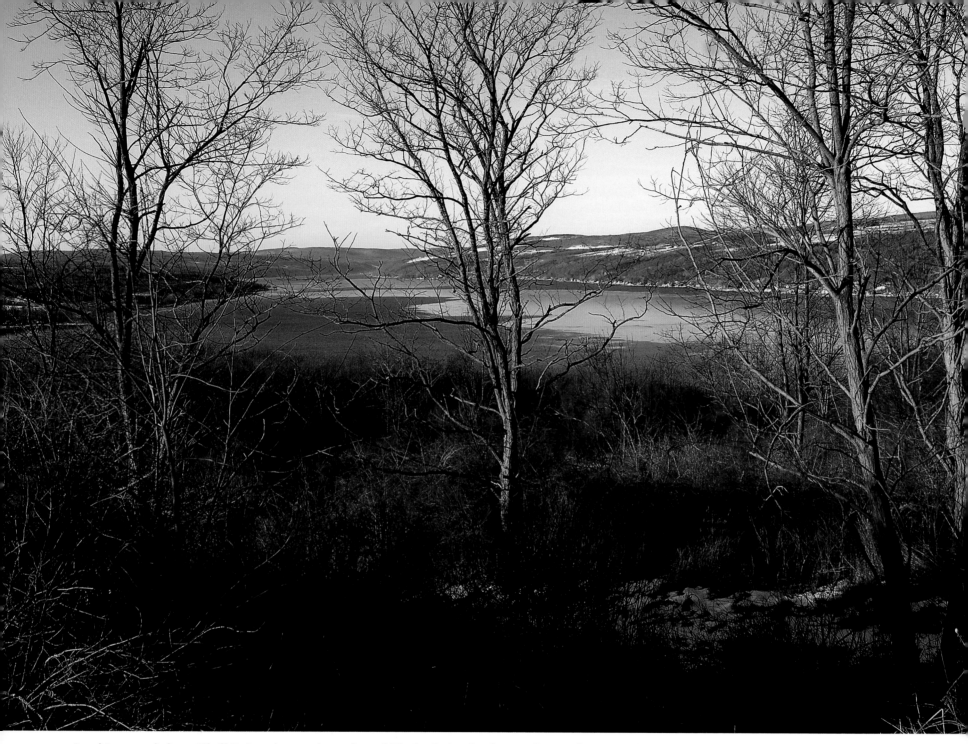

Looking south from Bluff Point, the two branches of Keuka Lake display ice floes in late March.

A darkened cornfield greets a new day as a magnificent sunrise paints the clouds over Cleveland Hill—part of the Bristol Hills.

Index of Locations

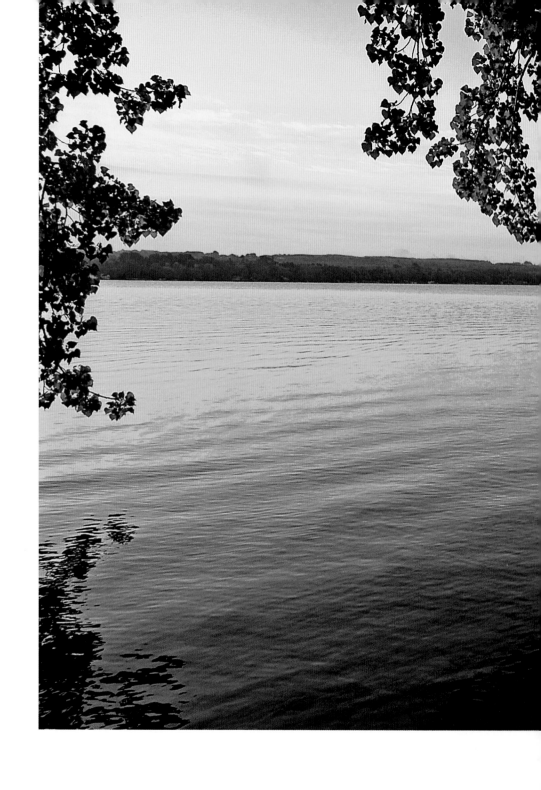

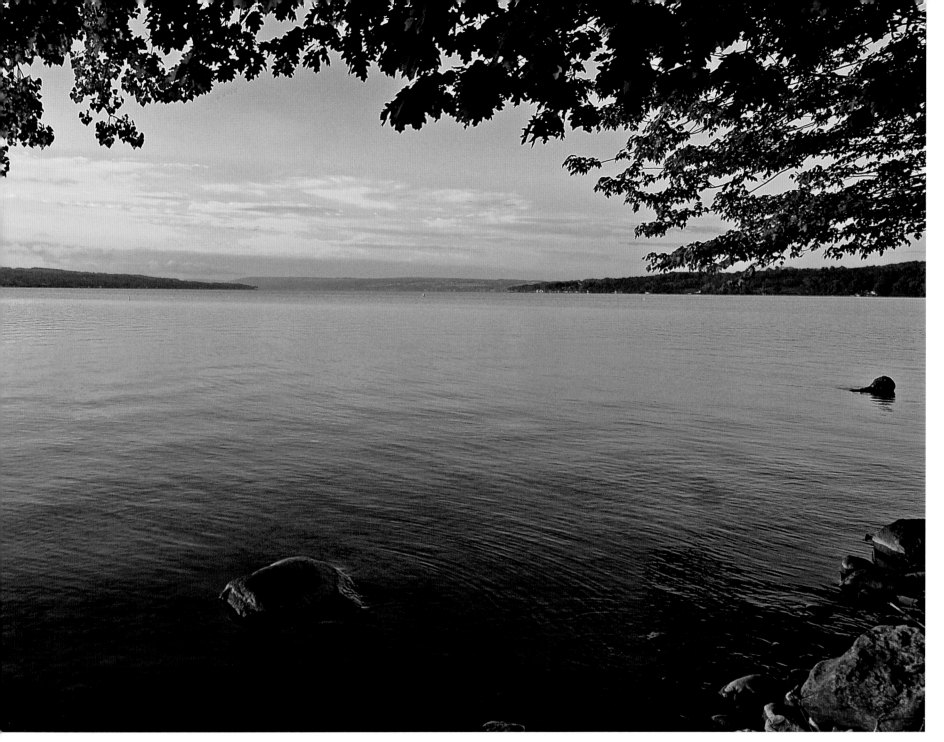

The very clear waters of Skaneateles make it one of the gems of the Finger Lakes. Looking south, you can see that its steeply sloped shores create the impression of a glacial fjord.